GHOSTS
of NEATH

GHOSTS
of NEATH

Robert King

AMBERLEY

First published 2012

Amberley Publishing
The Hill, Stroud
Gloucestershire, GL5 4EP

www.amberley-books.com

British Library Cataloguing in Publication Data.
A catalogue record for this book is available from the British Library.

ISBN 978 1 4456 0246 2

Typeset in 10pt on 12pt Sabon.
Typesetting and Origination by Amberley Publishing.
Printed in the UK.

Contents

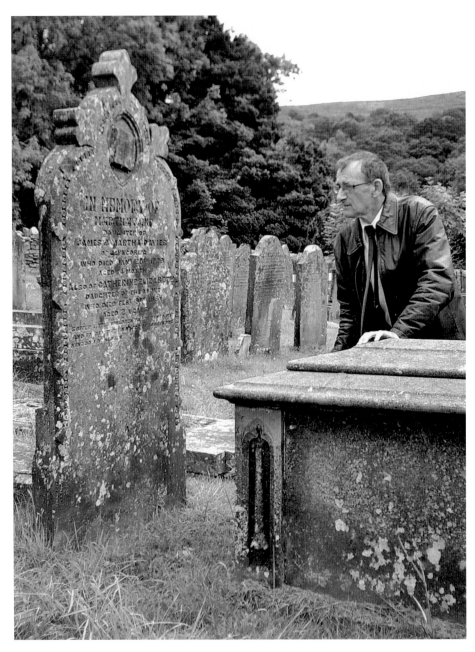

Author Robert King in a graveyard.

Acknowledgements

I'm grateful to the following people who have helped by relating their experiences to me over a number of years: Michael Davies, Barrie Flint, Glyn Davies, Tony Di Muzio, Barry Pugh, Darren King, Dr Paul Davies, Glyn Williams, Martyn Peters, Gwyn Bishop, Mrs Susan Fawcett-Gandy, Ian Ravenscroft, Mrs Bethan Morgan, James Rees, Amanda Llewellyn, Harriet Eaton, John Griffiths and Gerald Williams, the late John Blackmore, Paul Jenkins and Barbara Hzy. As ever I'm indebted to my wife, Joy, for her patience and for my long absences either in my upstairs room to write or wandering around graveyards and searching other aspects of my town's past.

References

David Rhys Phillips, *The History of the Vale of Neath* (1925)
Thoughts Like An Ocean (Pont Books, 1997)
The *Neath Guardian*, various years
Ymlaen, the community magazine for Dyffryn Clydach

Uncle Eddie

I always visited him on Saturday morning
Taking the currant cake my mother had made.
My Uncle Eddie.
'Sit there, Joe,' he always said, (calling me
By my father's name). He would smile; his
Toothless mouth moved from ear to ear.
'How are things?' he'd ask.
I'd smile but not without a little fear.
His home: old, cold, dark, dank…
He once told me he was buried in St Thomas'.
Only twelve years old I'd shiver as he seemed
To look through me! He'd sit crumpled up in old clothes,
His wrinkled hand would reach out for a log for the fire:
Damp wood hissed and to help this he'd spit, too.

Then I grew older and left home and those visits were a
Memory. He left that old terraced house and went to
Live with my aunty.
I saw him only once more but he'd remembered my calling
Those years before and asked: 'Will you ride in a horse race on the telly?'
'No. Not a chance,' I mocked.
I didn't realise then he knew.
Nine days later he died, (my mother told me on the phone).
My Uncle Eddie.
My brother told me he'd said: 'I'd love to see Joe win a race on the telly.'
My Uncle Eddie lived in his cold, damp, dark, dank home
Alone.
On the day they buried him in St Thomas' a chance ride in
A horse race at three pm. The time of his funeral.

They gathered in the rain amid the graves with Uncle Eddie;
A furlong out I cruised into the lead a hundred miles away
Winning the race with ease. Amid the cheering faces I saw
My Uncle Eddie.

Robert King

Published in *Thoughts Like An Ocean* (Pont Books, 1997)

Foreword

Since the publication three years ago about the haunted places in Neath I have received many more 'experiences' from people who had read the book and wanted to tell me about their stories. Some of them had attracted national attention, like the ones associated with the Castle Hotel; and in the case of PJ's Café, and the ghost of the Captain in the Duke of Wellington public house, international interest.

I thoroughly enjoy talking to people about the subject and writing down their anecdotes, and people are not often put off when I tell them that I intend to publish the stories. The subject is taken seriously by such a varied range of groups that I'm amazed by the interest: groups like the Rotarians, retired police officers' associations, church groups, WI groups and those serious-minded history groups. Without fail I leave those talks with a new story or sometimes several stories that I can follow up.

Neath's history goes back to Roman times, so the town has seen a plethora of change in every age. This makes the subject of Neath's ghosts (and other phenomena) a fulsome one – from the seventeenth- and eighteenth-century fairy stories, considered important enough by Neath's foremost historian, David Rhys Phillips, to be included in his magnificent tome *The History of the Vale of Neath*, to the more modern phenomena of UFOs, with everything from animal hauntings and 'angel' experiences in between.

A few stories from outside the Neath area have been included in this volume, but generally they have some connection with the town: Sker House, near Kenfig, was in the ownership of the Neath Abbey monastery, and the associated story about Elizabeth Williams, the original Maid of Sker, is relatively well known. What isn't so well known is that she was buried in Llansamlet churchyard. She was married to the engineer William Kirkhouse of Neath.

Some of the names of people who related stories to me have been changed to protect their anonymity. I understand and respect that stance. Others have given me their permission to use their names, having an 'I know what I seen' attitude, no matter how bizarre their experiences are.

I'm ever grateful to those who have been kind enough to allow me to hear the stories and to record them in this book.

Robert King
Abergarwed, 2012

Houses & Buildings

Ty Mawr, Neath Abbey Village

Ty Mawr translates from the Welsh as 'Big House', and it is certainly an imposing building. It was built in 1801/02 as the offices for the Neath Abbey Iron & Coal Company under the Cornish Quaker consortium of Fox, Tregelles & Price, who took the lease of the ironworks site in 1792 after Richard Parsons relinquished it. So, we have a building a little over 200 years old, with three storeys and a cellar area. As well as being used as offices, local historians believe that this commodious building was once the dwelling of Peter Price, one of the partners, and of his more illustrious son, Joseph Tregelles Price (although most addresses relating to the latter cite Glynvelin Cottage as his abode). Ty Mawr has now been converted into three separate dwellings, with two extra houses, smaller in size, attached to each end. There is a plaque on the wall of Ty Mawr, placed there in 1936, commemorating the fact that Joseph founded the Peace Society in 1836.

To many of us born and bred in Neath Abbey and deeply interested in our own past, Ty Mawr has a status akin to a stately home because of its association with the iron company. So it was with a degree of surprise that my friend Barrie Flint told me that the householder, Ian Ravenscroft, had experienced unusual happenings in the property.

Ian and his family have lived in the house for nine years and say that they have been happy there despite some remarkable occurrences, which started from the time they moved in. Ian said,

> We saw that house advertised for sale and we liked it immediately. It needed a great deal of work but we had time and felt that over a number of years we would get the place to our liking. There was a strange, heavy atmosphere

Ty Mawr.

about the house, and that was apart from the musty smell, when we saw it for the first time, but things like that don't bother me or my wife. Mind, we didn't realise the extent of the unexplainable events that would manifest. We should have been aware, I suppose, because when the lady estate agent came to show us the house the first time she wouldn't come inside. She insisted on waiting by the door, telling us 'You go in and look around, I'll wait here'. That was odd because such people are keen to sell property and walk around with you, giving it the big sell. She was decidedly uneasy but we didn't pick up on it. It took us six months to buy the house, which was frustrating. There was no chain, the house was empty and we had a mortgage in place. Problems with the vendor, signing documents, etc., which all shouldn't have been any problem, took ages.

Ian said that it didn't take long for strange things to start happening. For no reason inanimate objects would move.

We – my wife and I – didn't see them moving, we never have. But you put a bunch of keys on the table and you go to pick them up, sometimes only a few minutes later, and they have moved when no one else has been in the room. Then they are found on a sideboard the other side of the room and you know something funny is happening. Yes, you'll blame yourself for maybe being absent-minded, we all do things like that and often there is nothing in it, but when you are sure, you can become uneasy. Over the years we have got used to it, and odds and ends like keys, etc. have never been found too far from where we put them.

When we came here there was an imprint on the wall of a person, a man, we think, but we papered over it. There was also some writing, but we couldn't make out the words. They were strange scribbles.

Ian described other occurences, not uncommon where ghosts are reputed to have been active, such as the altering of television stations when no one was either using the handset or changing channels by using the buttons on the television set, and the computer experiencing malfunctions for no obvious reason. But he also talked about more bizarre situations, like the night an uncle slept on the settee in the living room. In the early hours of the morning he awoke to see a child playing on the floor. He watched as the little boy, who seemed suddenly aware that he was being watched, ran towards the wall and disappeared through it. That uncle will not visit the house now. Ian said that unbeknown to the uncle, and to many people who came to the house, the part of the wall that the child disappeared through was a bricked-up doorway that had led directly to the house next door, converted many years ago from a stable to a dwelling.

'The shadowy image of a man often appears in the doorway that leads from the living room to the hallway,' said Ian. 'It is difficult to make out what clothes

he is wearing. It would be helpful if we could because that might give us some guide as to the period this ghost lived in,' he added ruefully.

All the members of Ian's family have experienced the haunting in the house and they seem to have become used to it. They don't get flustered or frightened, although they all say they wish 'strange things' didn't happen. Ian continued: 'I know in advance that the ghosts are present. I get, for no other reason, goosebumps on my arms. The thing is that they haven't caused us harm. We just live with it. We do like the house.'

The upstairs rooms are not exempt from the ghosts. Much of the house is being renovated, so the usual fittings and fixtures are not all in place and the bathroom, which is located on the third storey, houses only the bathtub, Ian said that one night while in the bath there was the sound of drumming fingers on the side, on the enamel. 'It was so distinctive and it persisted for quite a few seconds. I had the distinct impression that someone was there.'

On hearing this revelation, my immediate response was to suggest to Ian that he should have spoken audibly and firmly to the 'entity' and told it not to be rude and to go away.

'I did,' said Ian, 'and the sound did stop. My goosebumps disappeared as well, and the whole atmosphere became lighter. That experience in the bath hasn't been replicated.'

He paused by the top of the stairs; we were still on the top floor. 'We have been told that a man committed suicide just there,' he said, pointing to the edge of the rail protecting one from the highest point of the stairwell. 'He is reputed to have hanged himself by tying the rope to the rail and then jumping. I can see him sometimes, only an outline ... I can see him now, he is there, my goosebumps,' he said slowly. His arms were covered in them. 'Sometimes from the room next to our bedroom we hear banging noises. We hear them quite often.' Their bedroom is located on the third storey, just behind the railed stairwell where the man is said to have hanged himself.

'That room isn't used,' he added. 'It's kept locked.'

As we descended the stairs Ian told us that a few years ago the family had gone on holiday and a neighbour had looked after the house. The neighbour, although living in the same building, had never experienced any 'disturbances' in his house. But when he came to check Ian's house, while walking towards the stairs he saw a man standing on the landing. 'Standing there, just watching', said Ian.

It seems that our neighbour saw a much more detailed apparition than we have. As I said, we see only glances of shadows, but many of them. The neighbour stopped and stared and the figure, dressed in clothes of the Victorian period, smiled at him and disappeared before his eyes. Our neighbour wasn't happy and only checked the front door after that until

we returned home. He was, though, relieved when he told us somewhat hesitantly about it, with an air that 'you are not going to believe this', and we said that we had seen similar things.

Back in the living room Ian said that only once had an experience been of a sinister nature.

There was persistent banging and sometimes we would feel someone or something pushing us in the back. We didn't like it; this was different and it was as though the 'presences' were objecting to us living here. We made contact with a respected exorcist from Neath. He wasn't a clergyman but was very religious – a devout Christian, but also a spiritualist. When he came into the house he paused and told us that there were many ghosts here. He prayed and scattered Holy Water in every room, including the stairs, hallways and landings. He said that there was a spirit present who harboured evil and harmful intentions and he concentrated on this, and since he came here the house has been calmer.

But one strange thing, and we continue to see it, is the figure of a man hanging onto the outside of the front window of the house, as though he is trying to get in. His face is contorted and angry. This window is on the third floor, some 50 or 60 feet from the ground. Maybe this was the sinister ghost, and the exorcist really did his job properly and cast him or it out of the house.

We can cope with many of the other strange things. Things like one night one of the children was in bed and the covers had fallen off him onto the floor. A lady appeared to us saying 'he's cold'.

There is the odd story about a figure, again. Ian thinks it's a man. He once pinched him while he was lying in bed, and then proceeded to lie on top of him, although Ian said there was no feeling of weight or any sensation as this happened. He did add though, 'I had to have a cup of tea after that!'

The house is compact and narrow following the alterations from offices to dwellings, and one can plainly see the haphazard manner in which those responsible redesigned the houses. 'I have been told by people who have lived in the other houses that strange things have occurred there, too; but it seems that nothing has been experienced quite like what we've seen, felt and heard.'

Ian knew that the building had been built by the Quaker families a little more than 200 years ago to service the administration of the Iron & Coal Company, but naturally didn't know who had occupied the building since that company ceased to exist. Any number of historical events could account for the hauntings. The child who played in the living room at night and ran through a wall that had once been a doorway into a stable block certainly

seems to emanate from those old industrial days; and the suicide from the third-floor stairwell banister clearly happened during the last hundred or so years. However, for the other the restless spirits there is no indication of who they are or why they continue to frequent the house.

It seems that the ghosts are set to remain in Ty Mawr, and as Ian and his wife told me, 'So are we. The family are used to them, they don't cause us any harm; we are used to the disruption and we dearly love the old house. They'll leave before we do.' A family with a degree of stolidity, they don't excite easily. Good luck to them.

Ty Mawr, as mentioned above, was built 1801/02, and initially Peter Price and his wife Anna lived there. They arrived from Cornwall in 1792, together with Peter's two brothers-in-law and his father-in-law Samuel Tregelles, and resided at Cadoxton Place, now roughly the site of Min-y-Coed, before relocating to the newly built Ty Mawr around ten years later. Peter Price was well respected as the iron master, setting up a free school in the village, and as a Quaker he worked diligently to improve the lives of the poor and distressed. He died on 13 September 1821. Some time later the building was used for offices servicing the Iron & Coal Company.

Consider the poem written by the renowned Elizabeth Davies of Neath, where she concludes in verse six:

Tho' earth is closed around the mortal frame,
The spirit's gone to God from whence it came.

For the illustrious Peter Price, let's hope the poet's words are right and that indeed 'the spirit's gone to God', and that it is not he who keeps today's residents of the Ty Mawr awake at night.

Neath Abbey Ruins

Among the oldest buildings in Neath, and arguably the most iconic, is the ruin of the church of St Mary, Neath Abbey. The ruins date from the Reformation (1536–39), when Thomas Cromwell, the Vicar General in the employ of Henry VIII, removed the monks, removed the roof and allowed the weather in. Nature did the rest. Those people whose souls haunt the Abbey naturally predate this.

In 1129 a charter was granted to the house of Savigny to establish a monastery on the banks of the Nedd. The house of Savigny collapsed a few years later and the Abbey's monks joined with the Cistercian order. Their ghosts continue to frequent the still and now jagged walls to the present day.

In 1326 King Edward II, in fear of his life, took sanctuary in the Abbey. He was being pursued by his enemies, among whom were his wife and her lover,

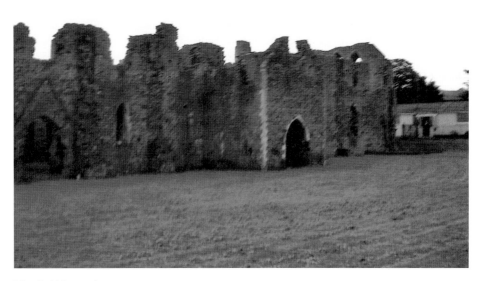

Neath Abbey ruins.

who aspired to kill him and seize the seals of state. At that time all monastic buildings were provided refuge from the law, so the King's enemies had to wait and watch until he decided to flee. For some ten days he was looked after by the monks until he made his escape.

The story goes that one of the brothers (or a lay brother) had conspired with Queen Isabella and Robert Mortimer, passing on information about the route the King would take on leaving the Abbey. The information proved correct, and King Edward was captured, taken to Berkeley Castle and executed. Upon hearing this, no doubt the abbot and his brethren were distressed. That distress turned to anger when they learned that one of their own number had divulged the route. Rumour has it that the traitor was killed and his body was not buried in consecrated ground. Does his ghost wander the precincts of the Abbey, seeking forgiveness?

Recently, while talking to Mr John Griffiths, the secretary of the Swansea Valley Historical Society, he asked me if I had known Tudor Walters, the radio and television actor, who lived until his death on Drummau Road, Neath Abbey? I told him that I had known him and had spoken to him many times; like me, he was a member of Gorffwysfa Chapel in Skewen.

John told me that he had known him through his work, and he had told him a story about a Neath Abbey man called Hubert Brown, who lived in

one of the cottages beyond the Tennant Canal, near the abbey ruins. While walking to his home one night in the early 1960s, Mr Brown was amazed to see the figure of a monk moving from the main entrance into the Abbey towards the site of the Abbey's church. Mr Brown had said that the figure was dressed in the typical garb one associates with monks. Mr Brown froze and just stared. The figure didn't appear to see him. It was walking quickly, head bent forward, its hand clutching a book. There was only a half-moon, but it afforded enough light for him to see the figure. The episode ended when the monk walked around a corner and disappeared. Mr Brown hurried home. He had passed this spot hundreds of times and had never before seen such a thing.

Mr Brown was a respected business man. Opposite the ruins at that time was a motorcycle speedway track, and the noise of the racing motor bikes and the hundreds of spectators it attracted certainly didn't seem to have any effect on our ghostly monk – otherwise, one would imagine, he would not haunt the place. There was no racing on the night Mr Brown saw it, but races took place a couple of times a month. Perhaps noise and activity caused and provoked by mankind in our busy world has no effect on those who have moved on from this life but somehow will not quite let go.

The Bridge Over the Canal

Mrs Barbara Hzy from Briton Ferry told me about the experience she had while sitting in her car outside Neath Abbey ruins. She wrote to me in 1976:

> It was between ten o'clock and midday. The weather was fine and clear. My husband and daughter went for a walk around the ruins. I was feeling unwell so opted to wait for them in the car.
>
> I was sitting, quite relaxed, when I saw the figure of a monk walking across the humpbacked bridge that spans the Tennant Canal. He looked like an ordinary person, in his thirties or forties, I think, with a pleasant-enough face. I watched intrigued, and as he stepped off the bridge, he vanished. I was in no way frightened. I had a feeling of loss that he had gone. He hadn't been rushing, just walking at a normal pace. Nevertheless I saw him for only a couple of seconds.

Mrs Hzy told me that she had gone for a walk around the Abbey sometime later with her husband, and when she got near the sub-dorter, or undercroft, she felt the temperature drop and sensed that something evil had once taken place there.

The bridge that the monk used to cross the canal was built soon after 1825, when the canal was developed – it runs from Aberdulais to Port Tennant in

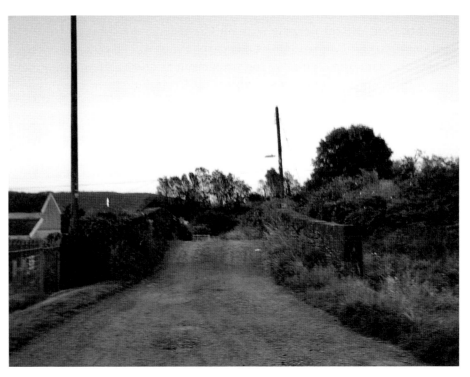

The bridge over the canal, where Mrs Hzy saw the figure of a monk.

Swansea. The monk would surely have left the Abbey no later than 1539 following the reformation. So clearly those who seem to cling to this life after death can make use of facilities that post-date them by a period of more than 200 years.

The Railway Embankment

Another sighting at the Abbey ruins was told to me by a gentleman who wishes to remain anonymous. He said:

It was in 1970. I was strolling along the railway embankment. It was a warm evening and I sat down and lit my pipe. I was facing the ruins.

It was about six o'clock and quite bright, and the atmosphere was one of solitude you'd expect to find at the Abbey. Sitting at this spot is something I had done hundreds of times. I was just staring blankly at the cragged walls, when I thought I saw a movement. I was well used to seeing people walking about visiting the ruins so I didn't pay too much attention. But then the suddenness of the movement caught my eye again. Now I began to watch earnestly. This time I saw it clearly. I became very uneasy as I

made out the definite shape of a person dressed in a mostly white habit. I remember it was with hope that I thought someone was playing about. The thing, for that is what it was, stopped walking [it had been going towards the wrought-iron fencing that bounds the River Clydach on the northern side of the Abbey. This is also the area where the monks were buried – it was their graveyard.] It looked in my direction. I rose to my feet slowly, and even though a good hundred yards separated us I was churning up inside. I felt a cold chill surround me, my throat went dry, and a numbness gripped my legs. It half-turned away from me and then promptly disappeared before my eyes.

I blinked and then turned and ran towards the main road in the village. I have never been near the place since, not even on an organised visit. I cannot explain what I saw and would not have believed it from someone else. But I did see it and I don't want to experience it again.

Sker House

Although being sister abbeys, the Cistercian houses at Margam and Neath and their respective abbots had their differences. At the time of the Dissolution of the Monasteries (1536–39) Neath was granted a stay of closure because it was in a fiscally sound state. Margam was not; it seems it had always struggled

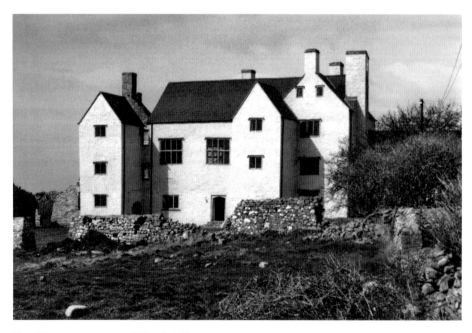

Sker House – a grange of Neath Abbey.

and Sker House, located near the rugged coastline at Kenfig, was given over to Neath by Margam to resolve a debt. Thus from the late thirteenth century to the Dissolution the property belonged to the monks of Neath Abbey.

The area of Kenfig is full of lore. Sker House is at its centre, and coupled with the Prince of Wales public house and the lost village it makes the area well worth visiting. Not far from the Sker House is the site where, in 1947, the *Santampa* came to grief with the loss of thirty-nine of its crew, together with all eight brave men of the Mumbles lifeboat who had put to sea trying to save them.

Following the Dissolution, Sker House was purchased by the Turberville family, who were devout Roman Catholics at a time when if you were caught practising Catholicism you could be put to death. Thus Sker House had its priest's holes, secreted between walls, behind fireplaces and through small, hidden doors under stairwells, where those priests who conducted Mass there could hide should the weight of the law descend upon them. This didn't help the Jesuit priest Philip Evans who was caught there, and following trial in Cardiff he was hung, drawn and quartered.

During the eighteenth century the house was occupied by a tenant farmer called Isaac Williams, whose daughter Elizabeth is considered to be the original Maid of Sker. It is said that she fell in love with Thomas Evan, a harpist from Nottage. Elizabeth's father didn't approve of Evan – the union would not have been a lucrative one – and to separate the couple he locked Elizabeth into a small upstairs room at Sker House. Her ghost is reputed to haunt the property to this day. Thomas Evan composed a ballad called 'Y Ferch o'r Sker'.

Isaac arranged a marriage for his daughter with an engineer from Neath called Thomas Kirkhouse. Legend has it that the union was an unhappy one, and Elizabeth died after only eight years of marriage. Despite this unhappiness, the union produced several children. Elizabeth was buried in St Samlet's churchyard, Llansamlet, where the grave remained lost until recently, when it was rediscovered by a group of people helping to tidy the area. One must assume that her ghost returned to that very room where she was kept a virtual prisoner to continue her haunting. Thomas Evan married another girl from the area, produced many children and lived well into his nineties.

The novelist Revd R. D. Blackmore spent time in Nottage and latched on to the story of the Maid of Sker, writing a novel of that name, which he considered a better work than his better-known *Lorna Doone*. Having read both, I consider *Lorna Doone* to be the more readable.

The Maid of Sker story is complicated by the fact that there was a similar one, dating from roughly the end of the eighteenth century; that of Martha Howells, the daughter of Morgan Howells. This story, too, has the ingredient of a love affair not approved of by the father. Neither story, it is said, is related by R. D. Blackmore. He heard the legends but nevertheless used his own poetic licence and created a fictitious tale.

During the twentieth century the house at Sker fell into a derelict state but was considered important enough to be purchased for the sum of £1 from Bridgend County Council by an historic trust that has renovated it almost to its original state. It was purchased by the historian Niall Fergusson and a condition was placed on the property that visitors could receive a conducted tour around the house on a number of days each year. I took advantage of that and made several visits with various groups. After a period of three years the condition was lifted and the tours ceased.

The ghost of the Maid of Sker isn't alone in haunting the house. She is joined by a monk who has been seen wandering the precincts of the building, in particular along a passageway known as Abbot's Walk. One wonders if the two ghosts meet across the wide time divide.

In Kenfig village itself, the Prince of Wales public house was originally built as the town hall, following the erosion of the old village by sand. All that can be seen of that village now is the remains of Norman Kenfig Castle, which in its day was attacked by both Llewelyn the Great and later by Owain Glyndwr, and the outline of the old village that surrounds it. The television programme *Time Team* has performed several 'digs' at the site.

AS a town hall, the Prince of Wales was the used for both manorial and borough courts. The building was also used as a school, a Sunday school and for cultural festivals such as *Mabsant*, the celebration of the patron saint. It is possible that it was at some cultural gathering here, the first Maid of Sker met her harpist lover, Thomas Evan.

Whether any imprint in time associated with the lovers makes itself known on sultry summer nights isn't known. When I visited the pub with my friend Barrie Flint, some years ago, the landlord was kind enough to give us a conducted tour of the building. He told us that he had on only one occasion felt a presence of uninvited guests. 'I was outside the pub one night and I heard voices calling each other. I couldn't hear them clearly enough to distinguish the names, but I was frightened and hurried back inside.'

Maybe Elizabeth and Thomas, although they have both passed through the veil, are still searching for each other.

The Rees' House

The following was related to Joy by a trainee estate agent working for Peter Short in Neath in the late 1980s. The house in question was located between Briton Ferry and Baglan.

A furniture van drew up outside the house – a familiar sight by now in the village. No one seemed to settle in the cottage for long before they moved on and the house became empty again.

View of the street where the Rees' house stands.

Everyone thought it such a shame, as there were many who remembered the cottage and the family who occupied it. Of course people move around a lot more these days, unlike previous generations who tended to stay put. But even so, people seemed fickle. Some who moved there said they loved it in the summer but in the winter the village seemed desolate and the cottage was cold. One said he fell in love with it when he first saw it, but after living in it for just six months he claimed that there was more work than he had thought to get the place right. Another couple who had bought it for their retirement and were coming down for weekends to do it up suddenly decided it was too time consuming. Another time, two couples who were friends bought it jointly to rent it out as an investment for their future, but after just a year they decided it was just too much hassle.

Now, sadly, the lady who had lived in it for just a year was moving out. She had retired here after having worked abroad for many years. She had bought the cottage with a view to maybe providing a bed and breakfast facility for tourists in the summer. An artist, she wanted to paint and exhibit her work locally. She made friends with the locals very quickly and most were glad to see the house occupied once more, but sadly the bookings were just not enough to give her the financial security she needed and she had sold very few of her paintings. It was with a heavy heart that she left, but, as she told

her neighbours, nothing had gone to plan, despite her love and enthusiasm for the cottage.

Some time later, the estate agent who was selling the property, yet again, called in to the house to check on things. While out in the garden he saw the next-door neighbour. He mentioned to her that she would have another new neighbour as it was up for sale yet again, and joked that she must be getting used to it now. She replied that she was not completely surprised as they had not yet managed to find the right people to live in the house. He was puzzled and asked her what exactly she meant. She invited him in, and over a cup of tea she told him the history of the house.

It had been built in around 1900. A widow, her son, daughter-in-law and granddaughter had moved in there from the other end of the town – the wrong side of town as it was considered in those days. A three-bedroomed house with a deep bay window in a respectable terrace would have been way beyond their means in those times, as the husband had been a humble steelworker in the local works.

It seemed that the widow, Mrs Rees, had a brother who had emigrated to America and done rather well for himself. He had enabled the family to purchase the house on condition that his sister lived there for the rest of her days.

Mrs Rees was a young widow and it had been a struggle to bring up her son; the purchase of the house had been a lifeline. It was usual for families in those days to live several generations under one roof and very soon the mother of Mrs Rees' daughter-in-law also came to live with them. She had been widowed and had to leave the cottage on the farm where her husband had worked. Sadly she soon became ill with what we recognise today to be dementia.

There were family stories of her trying to walk the several miles to the cemetery where her husband was buried and of standing in the garden calling his name. 'Owen. Owen. *Tyrd yn nol i fy.*' (Owen. Owen. Come back to me.) She was indeed inconsolable and utterly heartbroken.

The family were typical of the times. They went to chapel regularly and were always scrubbing, polishing and cleaning. They were very house proud. Mrs Rees was an accomplished baker of bread, pies and cakes; people would queue at the back door for her baked goods. There was a long garden where Hywel, her son, would grow all the family's vegetables, when he wasn't working twelve-hour shifts in front of the furnaces in the steelworks.

The little girl, Lizzie, was very talented. She could sing and play the piano and could draw very well. She had also been taught by Mrs Rees how to embroider and to stitch tapestry as well as the unglamorous job of darning her father's thick working socks.

The little girl was an only child and was a little bit spoiled, as typically her grandmother did not want her to suffer the poverty she had known. All her dresses were painstakingly made and her cardigans hand-knitted by her mother and grandmother.

The family had saved long and hard to buy the little girl a second-hand piano for her thirteenth birthday. Piano lessons followed, which Lizzie took to with ease, and she had passed her exams with flying colours. As time went on Lizzie began to tire of the constant practice for exams to attain even higher grades. She knew it pleased the whole family and her grandmother had great aspirations for her. She excelled at art and literature, and the family truly envisaged that armed with her education the young Lizzie would never, as her father put it, 'have to marry working boots'.

Unlike a lot of young ladies, as Lizzie got older she was not allowed to go to dances in the local parish hall. Her life consisted of piano exams and endless hours of practice. She played in chapel and embroidered samplers to sell in the chapel sale of work. She spent hours painting, and all in all led a very solitary life.

By now both grandmothers who lived with them were in poor health and she also had to help her mother who did all the household chores. With no other family members or friends the young girl found life very hard, so it was no surprise when a few years later she struck up a friendship with a young man, Roy, who lived in the next street.

Equally lonely, he had been injured in action in the Second World War, and was recovering slowly. His father, a tough, hard-working and hard-drinking man, had little time for his son, labelling him a mammy's boy. His mother worried about him but was worked off her feet taking in washing and various cleaning jobs as her husband drank all his wages in the pub before lurching home and falling into the front garden.

Roy would hobble around the back lanes of the houses, which is where he met Lizzie, and eventually they fell in love. Lizzie's family were horrified as Roy's family were definitely not chapel-going and the father was regarded as the town drunk. All the plans they had for her were going to be cruelly dashed. But young love won over, and amid terrible wrangling by both families the young couple married with just two witnesses in a registry office.

Roy's family regarded Lizzie and her family as snobbish and stuck-up, and felt Roy would not have an easy life. They were right. The family found fault with Roy's table manners, his lack of chapel attendance – even his job in the steelworks was a source of disappointment to them, even though steelworking was a part of their own family. Roy also liked a drink, whereas the family were 'temperance'.

Eventually, Roy told Lizzie he would have to go as he could not live in the constant hostile atmosphere, she could go with him or she could stay. Lizzie had never dirtied her hands or done any domestic chores, despite having being married and still living in her family home. She knew she would not be able to cope and would not have the financial security her family provided for her – something that made Roy feel ashamed, as it was clear they did not think he could provide a decent standard of living for their daughter.

She begged and pleaded with Roy not to go, but his mind was made up and he left. Her family adopted the 'we told you so' attitude and Lizzie was left broken-hearted. They were the centre of gossip in the village and chapel, and Lizzie had never been so miserable in her life.

In the meantime, Mrs Rees, her beloved grandmother, died and Lizzie felt her world had crashed in on her. Roy came to the garden gate to say how sorry he was, as he knew Mrs Rees had been a great source of comfort to Lizzie. He asked her again to come away with him, far away from here where they could start afresh. Lizzie agreed, feeling she had nothing left to stay for and knowing how much she loved Roy.

They made arrangements to meet outside of the village on Sunday night. Lizzie would pretend to have a cold, which would be her excuse not to go to chapel. Roy had managed to rent two rooms in a house some 20 miles away. He said they would manage. Lizzie was afraid but felt at least she would be with Roy.

The next few days dragged by, but eventually Sunday came around and Lizzie told her mother she felt a cold coming on and she would not be in chapel that night. Her mother sniffily agreed she had better stay by the fire. Once her mother had gone Lizzie threw some things in a bag, left a letter for her parents, and with her heart thumping made her way through the village, hoping she would not be seen as most of the people would be in their chapel pews.

It was an early winter night and Lizzie was not used to being out on her own in the dark. She was consoled by the fact Roy would be there waiting for her. She arrived at the spot where they had arranged to meet but there was no sign of Roy. It was dark and cold. Lizzie thought of her parents' reaction to the letter she had left them. Despite their being strict, she knew they loved her and had built their whole lives around her, sacrificing any spare money for piano lessons, music books and art lessons, and were still keeping her in clothes and things since she had married Roy. She loved them, but her life was now with Roy. They would be angry, but surely they would come round?

By now her feet were cold and she was getting more nervous. Suddenly a man appeared before her and startled her. He spoke her name and told her not to be frightened. He said he was a friend of Roy's. She asked him where he was, had he been held up? The man spoke to her hurriedly and told her he had been sent to meet her by Roy, and that he was not coming, not tonight or ever. In the time Roy and Lizzie had been apart, Roy had taken to spending time in various pubs and undesirable places. It seemed he had got entangled with a girl who was the daughter of one of the publicans, resulting in the girl becoming pregnant. The parents of the girl expected him to marry their daughter; they clearly did not know Roy was married. He was in a terrible state, the friend said, and did not know what to do. The girl's father was demanding they arrange a wedding. Roy did not want to involve Lizzie, as the girl's father was the type to go looking for Roy if he left with Lizzie as they had planned.

The friend said Roy could not bear to meet Lizzie with this news, as he had only been told of the girl's predicament in the few days since he and Lizzie made their arrangements. He was afraid for his life if he admitted he was married and afraid of losing Lizzie when she found out, and he knew what her parents would make of it. Lizzie and her family would be disgraced in the community.

Lizzie could scarcely take it in. She was heartbroken to think Roy could have got involved with another girl, let alone father her child. Then the thought of her parents reading the letter struck her, and of having to return home and tell them this news. She was rooted to the spot. The friend said he had to go and that Roy said he was sorry, that he really loved her but he didn't know what to do. She should go home and forget about him, tell people he had run off and let them think he was no good – better that than to be held to ridicule and the subject of gossip.

Lizzie made her way home and experienced the reaction she feared. They shouted at her and said that all the love and care and money they had spent on her was for nothing. Running off with a boy that was no good, despite the fact he was her husband, was that the thanks they got? She then told them that the situation was worse. Her mother said she could never show her face in chapel again, the village would turn their backs on them, they would be disgraced. They blamed her for bringing shame and trouble on the household.

A week later a policeman knocked on their door and said he had bad news for them. Roy had been found dead in a river, drowned they thought. They thought it was an accident but they didn't really know, as there was talk of him getting a girl in some bother. The policemen said her father was a fierce man who kept a wild pub and there was no knowing the goings-on there. He said he was sorry and left.

Lizzie became hysterical and her mother locked her in her room. All night her mother shrieked and wailed at how their lives had been ruined, overlooking the fact that Lizzie's life was turned upside down. Her father tried to console her mother while trying to come to terms with how this would affect Lizzie.

Lizzie could not eat or drink as she was so grief-stricken. Her mother cried constantly and would not put a foot over the door; she was inconsolable. One night, after much crying and berating Lizzie, she suddenly clutched her chest in agony. She fell back on the sofa. Lizzie screamed; her father ran out of the house and down the road to fetch Dr Lloyd. The doctor was just getting ready for bed, but when Lizzie's father banged on the door he threw his coat over his pyjamas and ran up the road clutching his black bag. Sadly, by the time he got there Lizzie's mother was dead.

Dr Lloyd told Lizzie and her father he thought all the worry and anxiety had probably contributed to her heart attack. Lizzie felt responsible and her father confirmed her feelings, blaming her for taking away his beloved wife.

From that time on her father just sat by the fire in what had been her mother's chair, staring into the embers. His garden was neglected, he did not want to see

anyone and found no consolation in his faith or in chapel, even refusing to see the chapel minister after the funeral.

He barely spoke to Lizzie, who felt she had been punished for falling in love with Roy and disobeying her parents by marrying him. All attempts to convey this to her father were ignored by him. He barely looked at her and spent hours walking up to the cemetery to sit by his wife's grave, where he wept.

On one such day he was gone a long time. Lizzie had prepared his dinner for him. She knew he would not eat, but she did not know what else to do. The only person she could talk to was Dr Lloyd, as she could not face chapel or anyone else just yet. Dr Lloyd told her it would take time for her father to grieve for her mother and it was up to her now to look after him. No mention was made, of course, of who would look after Lizzie.

By now it was getting dark. Her father's dinner was ruined and she was getting worried as to where he was. She put her coat on and decided to walk up to the cemetery, hoping to met him on his way home. Instead she met the same policeman who had come with the dreadful news of Roy's death. He was running towards her with his arms outstretched, telling her to go back.

He walked her back to the house, all the while trying to think of a way he could soften the blow for her, but as he sat her down in the living room he was forced to tell her that her father had been found dead, lying flat out on her mother's grave. He had taken his own life by stabbing himself in the chest with a knife he had taken from the kitchen.

He could not live without his wife and hated his daughter for meeting Roy, and for all the gossip and scandal that had resulted in his beloved dying from a heart attack. He had just wanted to be with her and could find no reason for going on. Dr Lloyd explained it to Lizzie as grief affecting the mind and said she was not to blame herself.

After her father's funeral, Lizzie found herself alone in the house. Some of the neighbours, feeling so sorry for the young girl and all she had been through, called with food and offers of help, and people from the chapel came and tried to offer comfort, but nothing could console poor Lizzie.

Eventually she knew she had to try and earn some income, but she had never worked in her life. The chapel minister suggested she should give piano lessons from the front parlour. He said it was a shame to let her talent go to waste. She agreed and had a very good response to the card she had put in the window of the corner shop. She turned her father's vegetable garden in to a flower garden, which she had always wanted. She took up painting again, but apart from chapel every Sunday, where few people spoke to her, Lizzie rarely went out of the house and did not encourage any visitors.

Every evening she sat with Roy's picture on her lap and wept over it. She was convinced that all the tragedy that had befallen her was the result of her meeting with him, and yet she still loved him.

The years passed and Lizzie became a reclusive spinster who gave music lessons and helped many on to a musical career. She could be heard playing long into the night; wonderful classical pieces that professional pianists would have struggled with. No one complained as the music was so beautiful and it seemed to be the only thing that consoled poor Lizzie – or indeed 'poor mad Lizzie', as she became known to the local children. All offers of help were shunned and slowly the house fell in to a state of disrepair. Several neighbours kept an eye on her, but there was nothing much they could do as she rejected all attempts at communication.

One day a neighbour noticed that her curtains had not been drawn and her beautiful piano playing had not been heard for a while. Eventually Mrs Rogers next door persuaded her husband to go round and investigate. After several minutes of knocking and calling her name through the letter box, Mr Rogers decided to break in through the locked back door. He took his brother John with him, and several of the neighbours gathered outside, concerned that Lizzie might be ill and in need of some help.

When Mr Rogers and John entered the house they came upon Lizzie lying motionless on the sofa, clutching a creased picture of Roy. The room was cold and the fire had not been cleaned out. Ashes spilled out of the grate. A layer of dust covered everything except the piano that her family had lovingly saved to buy her when she was young and they had such aspirations for her future. On the piano there were pages and pages of music score – love songs she had written about pain and betrayal, tragedy and heartbreak, all dedicated to her beloved Roy and written in her tiny, neat handwriting.

Dr Lloyd declared that the post-mortem found no obvious cause of her death, but he believed she had died of a broken heart. She was just thirty-eight years old.

The house was cleared, closed up and sold, as was her beloved piano. It stood empty for a while and then it was bought by a couple from London as a holiday home, with the intention of one day retiring there.

On one of their visits, they came around and asked the neighbour whether she had heard someone playing the piano during the night. It had disturbed their sleep. The neighbour replied she had not heard anything. They also mentioned that they had heard raised voices on previous visits. They complained that they came to get away and have some peace and quiet, and were annoyed that the locals were noisy. She cautiously said nothing, but a while later the house was up for sale and she never saw them again.

It was the same thing every time, whoever lived there. Another couple who bought the place liked country music, but found that their radio mysteriously changed channels to the classical station. They also heard raised voices often, especially when they returned home from the local pub. They turned the flower garden into a vegetable garden, but awoke one morning to find it destroyed, with the plants strewn over the path. After just a year they moved out, blaming

the locals for playing tricks on them in their garden and deliberately playing weird music to drive them out.

The lady who wanted to run a bed and breakfast was devastated when her attempts failed. The few guests she had all complained that the rooms were cold, despite the fact that the house had central heating, and she had also been accused of playing music until all hours, keeping them awake. Indeed, she was convinced her neighbours next door had a bad relationship as she was woken often by raised voices.

'So you see,' said the neighbour to the estate agent, 'It's Lizzie. She doesn't want anyone in the house, I think she sees it as an intrusion into her privacy. She does not want any music played that is not classical music. She wants to be left alone to play her music into the early hours, as it was the only thing she found consolation in. She hated vegetables in the garden, as it reminded her of her father. She preferred flowers and spent hours tending the garden. She objects to people who drink living there, as the family did not believe in drink, and it was drink and the girl in the crude pub that took her love, Roy, away from her. You have to take all this in consideration when you sell the house.'

The estate agent looked at the neighbour, perplexed and wide-eyed.

'Well I don't think many people really believe in that kind of crazy stuff, do they? It's more likely to be neighbours being resentful to what they call incomers, isn't it?' He asked, accusingly. 'I think they're barmy,' he went on, 'especially going to the lengths of playing weird classical music and ripping up gardens. It's the chapel-going lot disapproving of the pub and those that frequent it. They need to get a life. Nutters, all of them,' he muttered, as he got up to leave.

The neighbour felt very offended by his attitude. Although she realised the ghost theory was strange, she had fond memories of Lizzie and felt deeply for her, but was not able to help her much. And yes, she admitted to herself, it was difficult to see strangers in the house, but life had to go on. She watched the estate agent drive away. Fool, she thought.

When he arrived back in the office, he told everyone about his visit:

Can you believe it?! There are lunatics believing this stuff. It's more like a conspiracy against new people moving in by these village idiots. Some crazy woman lived there who was dumped by a guy who found someone else and got her in bother. The girl's father probably killed him and threw him in the river. The girl he was married to did not find anyone else and went batty, the mother died from a heart attack and the father stabbed himself. The daughter became a crazy old girl and played the piano all night. Sounds like something from a weird horror film. They are all nuts I tell you. I would not want to live there, but we have to put it back on the books. We just need some old bird who is as batty as they are and we are sorted. But where are we going to find one?

The phone rang and he spun around in his office chair. 'With any luck this will be her now,' he laughed. 'How can I help you?' he loudly chortled down the line.

'I am interested in a house you have advertised. I want somewhere quiet, with a long garden; I'm a keen gardener. I live alone, you see, and don't want somewhere I will be too bothered by neighbours. And I want a room I can use for my music,' the caller explained.

The estate agent stopped chewing gum and sat up straight. He placed his hand over the receiver and announced to the office staff, 'Someone is enquiring about that house.'

He turned back to the phone. 'Certainly, you can view the property this afternoon. Can I have your name please?'

'Yes,' the caller replied, 'it's Miss Rees. Miss Lizzie Rees.'

Coincidence? Whatever it was, it freaked the estate agent out!

Kathy from the estate agent in question told Joy that the house was sold to Lizzie Rees, and as far as she knows no disturbance or trouble was ever reported as happening there again.

The Monied Angel

Stories of ghosts having the ability to move inanimate objects are not uncommon. After all, most examples of hauntings have doors closing or banging, windows mysteriously opening, furniture moved around, and things disappearing and then reappearing in a different place. When we put something down and then can't find it again, we usually put it down to poor memory. Catholics will pray to St Anthony to intercede and guide one to the lost article, and strangely this line of action is often successful. In the following case, a young mother desperately short of money suddenly found paper money and coins of the realm turning up in her house in the most unusual places.

I've heard a similar story before about a man who owned a garage in England who was experiencing a haunting in his workshop. He too started to find money on his workbench, on the floor and in his toolbox. He certainly hadn't put the money in these places but it was there. As in Elizabeth's story below, when they were found the coins were very warm to the touch. This can't be explained, nor can the appearance of the cash. But where had it come from? Those in the spirit world have no use for it, so had the ghosts stolen it and then placed it where it could be found?

Elizabeth's story goes back twenty years, to the time when her house was built on the site of an old chapel. Again, this isn't unusual. Many places of worship have been converted into dwellings or have been used for some other purpose; more often than not they are demolished and the land they once occupied is developed.

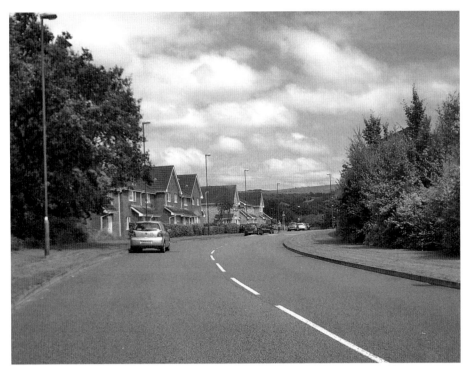

View of the houses on the street visited by Bethany Baker.

Some people in the village were sad to see the chapel close. The once-vibrant community had attended three times on a Sunday, together with the usual weekday evening meetings, such as the Band of Hope or practices for the *Gymanfa Ganu*. The twice-weekly gatherings to perfect the Nativity play from late October every year. The solemn occasions when members died and the coffin was carried to the front and placed just before the 'big seats' in the well of the pulpit, followed by the mournful singing, always in Welsh, of the funeral hymns. The joyful times when weddings were held there, making the atmosphere light and happy. All had left their mark on the old chapel, which was now boarded up. The chapel house next door was also empty, and a grey and dusty air had fallen over the whole place.

Membership had dropped to half a dozen ladies, and the Sunday service only attracted four or five into the congregation. The children of the older families had moved away, usually to find work.

There were many fond memories but there was nothing to be done, and gradually the building fell to neglect. One of the ladies, Bethany Baker, had once lived in the chapel house. She continued to live in the village, but was heartbroken to see the chapel's demise. Many generations of her family had been involved in the organisation, holding several positions of responsibility; indeed, her parents had met there when her father's family moved into the

area. The same had happened with her husband. Her in-laws had come to live locally and started to attend the chapel. Bethany and her late husband had started courting after the chapel services, walking home 'the long route', as she used to say. Now, following the demolition of the chapel, she would on occasions attend a service some miles away, but usually she didn't attend any place of worship. The main problem was transport. Only if friends were able to give her a lift did she venture from her home.

She had helped many people in the past when food was scarce and there was no work available for the men. Many more children would have run around without shoes but for her and the other ladies. She would visit young mothers, the elderly and the sick. There were times in the winter when she would be gone for hours, helping various families.

The years passed and Bethany died. Her funeral service was held in the next town, where she was not really known. For someone who had been a moving force in her own village, the funeral was somewhat anonymous.

Some twenty years later the building had been demolished and new, modern houses built on the site. There was no plaque to commemorate the fact that the revivalist Evan Roberts had conducted a prayer meeting in the old chapel. On the neat streets and cul-de-sacs built on the chapel site there wasn't even an 'Evan Roberts Close' or the like. Such were the times that many chapels and little churches were closing and their history forgotten and lost.

Elizabeth and her new husband moved into one of the houses, and although they were thrilled to have their own home, it was going to be a financial struggle for them. They had a six-month-old daughter and they had arranged that when her husband came home she would work a few evenings in the local pub and restaurant. The money was badly needed. She was quiet and sometimes struggled to make friends. When her shift at the pub was finished she just wanted to get home. There was not a lot to do in the village and the thought of the mother and baby group terrified her.

She began to feel lonely and isolated. Her family lived an hour away and her husband's mother was a career woman, not given to family matters much. They had come to the area as houses were cheaper than in other places, but it was still a struggle.

Her husband was offered promotion in his firm, and more money, but it meant he would have to work further away from home. Now Elizabeth could not even go to work. With her husband spending much more time away, she had to take care of the baby alone full-time. They were a little better off but not much.

One winter's night, her husband was late arriving home. She was beginning to worry, when suddenly the phone rang. It was the hospital some hundred miles away. Her husband had fallen asleep at the wheel of his vehicle. He was not seriously hurt but did have a broken leg and arm as well as a few bruises. He was being kept in hospital, and he would be off work for some time. This

was going to cause a huge problem, because her husband's contract with his employer meant that he would not be paid when off work.

Just when she felt they were keeping their heads above water, this setback sent her in to a spiral of worry and anxiety. How would they manage? She was the youngest in her family and her parents were elderly. She could never have asked for help, as her mother had warned her they were stretching themselves when they moved in to the new house. Maybe her mother was right, but she would never admit it to her. Her mother did not like her husband, as she thought he and his family looked down on her daughter and themselves.

Other people living in the village had their families living nearby – how she envied them. There was a strong sense of community in the village, which only served to make her far more aware of how lonely she was.

Her husband came home from hospital and was very agitated by the fact he would be off work for some time. In fact he was permanently agitated by having to be at home, something he was not used to. The little girl's crying annoyed him, the sound of the television annoyed him, next door's dog barking annoyed him, and very soon he was severely depressed. He refused to ask his parents for help, keeping the phone conversations with them to a bare minimum.

It would be Christmas in three weeks' time, but they had no money for presents. Even buying food was a struggle and the husband was in no fit state to look after his daughter and enable his wife to work.

Elizabeth went to bed each night and cried herself to sleep. She did not know what would become of them. Life for their generation was not supposed to be like this. She had listened for years to her mother's stories of the hardships she endured as a child and of her struggles to bring seven children up. She had been the youngest and was rather oblivious to all of it. She had been glad to get away and begin her own life, but she was in just as much of a mess as her mother had been, just a more modern version of it.

Now she was trying not to turn the central heating on in midwinter. She had a car outside that she could not afford to put petrol in. She was heartbroken that she could not give her little one the things she had been looking forward to buying for her. Any money they had saved had been used to pay bills. The sickness benefit was barely enough to live on. She had never felt so desolate. She had tried to buy a Christmas tree but the prices were just too high, and it was more important they had food; a tree was not really essential. They had not even discussed buying presents for each other; that was out of the question.

Because of her husband's restlessness, Elizabeth had taken to sleeping in the spare bedroom. Although unconventional, this arrangement suited them both. The constant lack of money occupied her mind, causing her to lie awake most nights worrying about rate bills, the various utility bills, the baby's clothes, and so on.

Early in January Elizabeth's husband had been picked up by a work colleague. Although still using a crutch to aid his walking with a mending leg, he was trying to pick up his work again. It was a bright day, and although it was cold she wrapped the baby up and went for a walk with the push chair. At the end of the cul-de-sac a young man was busy taking photographs. As she passed him, he said, 'Hello, just taking some snaps of the area. I've got pictures of the area as it was years ago with the chapel. I'm putting them in a "Then and Now" book,' he said enthusiastically. Elizabeth had heard about the chapel but only in brief comments in the local shop. She nodded to him and continued on her way.

When she arrived home the postman had left several letters, two of which were demands for payment for the council rate and the gas. She opened them and sat down, failing to hold back the tears. The baby started to cry, probably in response to Elizabeth's grief. Suddenly she heard the back door banging. The door had not only been closed, it had been locked. She was startled but thought it was simply her husband returning early. She went to see, but everything was as it had been. The door was still locked. She was still holding the letters and placed them on the kitchen table. Then she noticed a £20 note sticking out from underneath a vase of flowers she had placed on the table a few days ago.

She looked at it without moving. Gently lifting the vase, she took the money. It was a brand new note, no creases or marks. She couldn't imagine that her husband had put it there. She left it on the table.

She turned to boil the kettle to make tea. The baby had now fallen asleep. It was so peaceful. She opened the cupboard for the teabags and sugar and, as she placed them next to the kettle, five brand-new pound coins chinked or clattered on to the draining board, which was alongside her. She just stared at them. They were shining and new.

She reached out and picked one up, and immediately dropped it on to the floor. It was hot to the touch. She jumped back in horror. What was happening? Behind her she heard the sound of the radio. But she had not put it on. Only the baby was in that room and she was asleep, not that she could have switched it on anyway.

She didn't turn the radio off, but sat down near the baby. She was scared and wished that her husband would come home. The radio babbled away and then a local story about a man who was writing a history of the village came on. 'I've been out taking pictures,' he said, and Elizabeth recognised the voice of the enthusiastic young man who had spoken to her a few hours ago. 'The chapel is interesting,' he said, 'and the story of Bethany Baker, who was a lady we'd describe today as one who was always doing good works. She would prepare food parcels for the needy and was often raising money for charity. I'm dedicating a chapter to her. She lived in the old chapel house.'

Elizabeth picked up the £20 note and the five £1 coins, which were cool now and didn't burn her fingers, and placed them in a cup on the sideboard.

Later that evening her husband returned home, and he too had a fit of depression when he saw the demands for payment of the rates and gas. 'We owe more than a hundred pounds between these,' he said. 'We've got seven days to pay them or else ...'

As in past nights, Elizabeth tossed and turned in bed unable to sleep. What would become of them? She put the bedroom light on to check the time, squinting with the glare of the light, and saw that it was just past midnight. Sleep was a million miles away, and she decided to go downstairs and make herself some tea.

Feeling her way so as not to put the landing lights on and risk disturbing her husband, she carefully slid her hand down the banister, taking just a step at a time. Once downstairs she put a light on and made her way to the kitchen. Leaning over the sink unit was the figure of a woman. Elizabeth just stared, quite unable to move. The woman was fumbling about in the cupboard. The light being turned on didn't seem to bother her. Elizabeth blinked, wondering if she was dreaming. But no, she was looking at the back of a woman. A short person dressed in a red cardigan over a blouse and a black skirt almost down to her ankles. On her feet were black brogues.

Elizabeth walked backwards ready to hit the stairs light and run up to her husband, grabbing the baby on the way. But then the woman turned and looked at her. Smiling, she said 'I will help you'. Then she literally disappeared. Elizabeth screamed and ran up the stairs.

Breathlessly she tried to tell her husband what she'd seen. He tried to console her. Then she told him about the money she'd found in the house. They went downstairs and she took down the cup. The £25 was there.

'I didn't leave it around,' he said. 'I can't understand.'

Elizabeth had regained some of her composure now that he husband was awake and with her. She lifted down the teabag container and opened it. Inside was a £50 note. 'What ... ?'

Her husband took it, unable to believe what he was holding.

'The woman had that cupboard door open when I saw her,' said Elizabeth.

They were both unable to understand or analyse it, and went back to bed, this time in the same room. Sleep didn't come, but they talked about so many theories that they confused themselves.

'Well, we can pay the rate demand,' her husband said. 'That's seventy quid; somehow seventy-five has turned up. Maybe we shouldn't think too hard about it, just accept it.'

During the following days, more money appeared. Elizabeth did have a fleeting glance of the woman one morning. She had put the baby in the pushchair in readiness to go to the shop and the woman was in the living room gently rocking the pushchair and quietly singing to the child in Welsh. Elizabeth couldn't understand the language, so the words were lost on her. When she appeared at the door the woman disappeared. In the pushchair Elizabeth found another £50 note.

The money kept turning up, and they counted up that they had found more than £1,000 in the house in notes and coins (always £1 coins). 'This has got us out of a lumber,' her husband said.

Some months later, the finds had virtually dried up, but occasionally a note or two would be found, usually in the kitchen.

Elizabeth was in the shop and on the counter was a stack of books. The young man's history of the area had been published. As she fingered from page to page she saw a picture of her house and alongside it was a picture of the old chapel house. A caption under the pictures read: 'On this site was Chapel House, the home of Bethany Baker, a local charity worker.'

Bethany Baker's image was on the adjacent page: she had the same smile, the same clothes, the same demeanour as the lady she'd seen rocking the baby in the pushchair. Bethany Baker was continuing to perform charitable work from beyond the grave. Elizabeth was trembling and near to tears. 'I'll have a copy,' she said.

The shopkeeper smiled and said they were flying out. 'Have you seen the piece about Bethany Baker?'

Elizabeth nodded and hurried home.

I asked Elizabeth about the legal tender status of the money that had been found in the house. She said that her husband had questioned this and had taken it to the bank and paid it into his account. He rightly assumed that the bank would check the notes to see if they were genuine. There was never a problem.

So we can conclude that those who have been this way before us can return and access and make use of money of our realm. Let's hope they use it wisely every time.

Tyn-yr-Heol, Tonna

A white lady is said to haunt the precincts of the now-demolished Tyn-yr-Heol House in the village of Tonna. This is said to be the ghost of Jenny Jones, a harpist who was a prizewinner at the 1883 National Eisteddfod held in Cardiff. *The History of the Vale of Neath* relates:

> The people of the neighbourhood said that after her death and invisible figure came at night to play upon the harp in an upper room – the favourite harp which the gentle lady used to play with acknowledged skill.

Author David Rhys Phillips continues in a footnote:

> A harp-playing relative of ours, having heard the story, went to the late Mr Williams Jones (the last of his line) at Tyn-yr-Heol and asked if he might be allowed to see the harp?

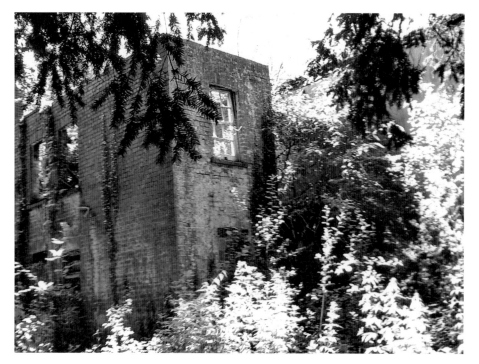

The remains of Tyn-yr-Heol house.

'Of course,' was the genial reply.

Mr Jones went upstairs and brought down the neglected instrument and handing it to the visitor (whom he had long known) and said: 'Take it away with you.' Although taken aback at having another instrument thrust upon him, he assumed that the harp being absent [from the house], the rumoured playing by an invisible figure, which unnerved the domestics, would now come to an end.

The sometimes plaintive sound of a harp being played, particularly at night, might not have been heard again at Tyn-yr-Heol, but ever since that time many people have reported seeing a lady clad in a white dress wandering around what were the grounds of the house, which is now in a sadly dilapidated state. Maybe she is looking for her harp?

The White Lady of Rheola

The imposing mansion of Rheola, thought to have been built on the site of a farm at the turn of the nineteenth century, is now the only 'large house' left in the Vale of Neath. It was the seat of Edwards-Vaughan family.

Work to transform the building from a farmhouse into a mansion was carried out by John Edwards around 1812/13. Edwards was a parliamentary solicitor of Regent Street, London. He purchased the estate from Capel Hanbury Leigh and his wife, Molly, the widow of Sir Robert Mackworth of the Gnoll in Neath. Elis Jenkins, the late historian, was the first to attribute the work on the house to John Nash. It is now accepted that Nash was certainly the architect.

John Horner was one of many artists attracted to the Vale of Neath, and in 1815 he produced several paintings of the house. One, which he called *Saturday Morning*, has been reproduced as a print and appears in many publications. It depicts horses, hounds and carriages outside the house, which looks in the painting much as it does today.

The name Edwards-Vaughan was created in 1829 when William Vaughan of Llanlai passed away, bequeathing his property to John Edwards

A grandson of this John Edwards, John Edwards-Vaughan, who was born in 1863 at Llanlai, had a daughter who was married to Captain Mark Haggard of the Welsh Regiment; he was the nephew of the novelist, Rider Haggard. Captain Haggard died in France in 1915.

In the twentieth century the mansion was in the ownership of Rheola Aluminium Company. When the works closed in the 1980s the house and the surrounding land was purchased in the early nineties by Mr Ron Rees of Resolven and has passed down to his son, Mr Howard Rees, who is currently working to renovate the house.

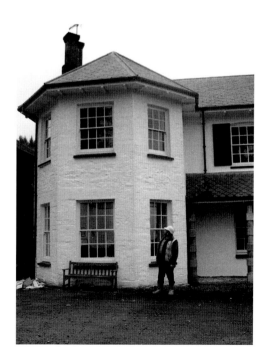

Mr Howard Rees looking up at the haunted room in Rheola House.

The story of a lady haunting the house and grounds has been known for many years and is referenced in Rhys Phillips's *The History of the Vale of Neath*.

But we are concerned now with the continued sightings of the ghost and those in particular recorded by the house's present owner, the genial Mr Howard Rees, who now takes up the story:

Together with my wife I live in the part of the building that was the servants' quarters. This is almost an annexe to the main house, joined to it by a corridor on the first floor that links to a room above what is now an office. That upstairs room was used as a nursery in the halcyon days of the mansion. Whether the nursery was used by the children of the staff, or the gentry, or both, the records don't say. But considering that the ghost of Rheola House is seen in the upstairs room, it would seem likely that both the staff and family members made use of that room for the small children.

Sometimes when walking towards the house I see the figure in the window of the room. She is sometimes seen holding a baby and sometimes not. She is wearing a white bonnet on her head, the type with pieces coming down and covering the ears and a neat tie under the chin; her clothes are smock-like, black in colour and covered by a white apron. There is always a sad expression on her face.

It can be unnerving when I'm walking towards the house and she appears, particularly if darkness is falling, but she had never caused us any harm and generally isn't disruptive. It's a case of steeling myself and going about my business despite her presence.

The house is undergoing renovation and she is most active when a great deal of work is being carried out. Her presence is felt then by doors being banged loudly in the nursery. Lights may come on and sometimes keys are heard being turned in their locks. I'm not the only one to have experienced these sounds, my wife has too.

I asked Howard what period he thought she occupied in her earthly existence?

I don't know whether she's from 1809, when the house was first built, or even 1909. The story is that she was a servant girl who drowned in the lake – there is a large lake between the mansion and the B4242 road. Whether she met her end by drowning or whether she hanged herself, I don't know. It wasn't uncommon for girls of her status to become pregnant, sometimes by members of the gentry or male servants. All I know is that she won't let go of the place.

As I said, I'm not alone in seeing her. Some years ago, in my father's time, we employed a carpetfitter from Neath to lay a carpet in one of the large downstairs room. We helped him carry the material into the house and asked

him if he was all right on his own to continue his work. He said he was so we carried on with other work quite some way from the house.

Some hours later we returned and the man was sitting outside the front looking rather uncomfortable. 'Everything alright?' I asked him.

'No,' he said, his voice tinged with both anger and fear. 'Who's that girl in the house? You told me no one else was here. She appeared behind me holding a baby, dressed in old clothes and then she disappeared. I didn't like it. I came out here then. I'm not working in there again.' And with that he demanded payment and left.

I have had two mediums here to try and make sense of it. The first one came in through the front door of the house, stepped into the hall and stopped. She refused to come further saying that there were so many ghosts here she couldn't cope with it all. Like the carpetfitter, she left hurriedly.

Then we had a lady medium from Cardiff who sat in the room below the nursery. She went into a trance-like state and seemed to communicate with the spirit world, telling us that the girl was in the room. We couldn't see her, though. The lady continued saying that she thought the girl had become pregnant (from what we knew that seemed right – the medium wouldn't have known that before) and had died. The medium didn't throw any light on how she died.

But she said that the girl continued to haunt the house, trying to communicate with the Lord of the Manor. Maybe, although we don't know the period, it was a man of this status who had fathered her unborn child. The medium continued, saying that she had returned to show the father the result of his or their passion. Then she said, 'You now own the house. She can't differentiate between you as the owner and the Lord of the Manor in her time.'

It has been suggested to me that I carry out a search of the old newspapers that circulated the Neath/Swansea area trying to find a reference to a tragic death here, such as a drowning or someone hanging themselves. I haven't done that, but the medium suggested that such events, particularly if a member of the house's family was involved in getting the girl pregnant, might have been 'covered up', allowing the impropriety to disappear. Whatever, it was this girl who is still in this house, now with a child in her arms, who was the victim.

I asked Howard if he had considered asking an exorcist to cleanse the house. He said that he had considered it but hadn't done so. Perplexed, he added:

She clearly wants to be here. She isn't really disruptive and is not threatening. Surely if she wanted to go to what they call 'the light' then she would.

We are currently working closely with Neath Port Talbot County Borough Council's leisure and historical officers. The aim is to make the entire site available to tourism in some way. One afternoon I was sitting in this room

– we were in the room now used as an office and the one that is directly below the room used in years past as a nursery – together with an officer of the council and two lady secretaries, and as we discussed further renovation and development of the house and the grounds, an almighty bang came from upstairs. There was no one else in the house. There was a feeling of coldness in the room and the two secretaries became very uncomfortable and left the house. They were quite frightened.

Was it because we were talking about the house being pulled about – things being done, things being altered – and the girl was expressing her anxiety about the work? I don't know.

But no, I haven't had a priest here and probably won't. I have lived with this girl's presence for nearly thirty years and it will probably continue. She has as much right as we have, more right maybe, to be here at Rheola.

Howard Rees has cast more light on the story recorded by Rhys Phillips in his much acclaimed tome *The History of the Vale of Neath*. I have never before heard of a story like this haunting: a story where a pregnant lass dies, by her own hand or not, and then returns to haunt with the baby born and being carried by the victim. This is a spooky but sad story of a young lady who clearly departed this life in a distressed state attempting to make her mark and to draw more attention to herself in the spirit world. Rhys Phillips' 'White Lady of Rheola' has some substance now, and she will probably announce herself to others in years to come.

The Phantom at Rheola Market

Not long after I had spoken to Howard Rees of Rheola House regarding the uneasy spirit of the young girl, he phoned me to tell me about another experience that one of his employees had, this time in the building that houses both the Saturday market and boot sale. This market could well be the biggest in Wales, with hundreds of stalls, and attract thousands of visitors every weekend.

When I called in to see Mr Rees, the building, once part of British Aluminium's Rheola Works, was virtually empty. I was told that a caravan that had been parked in the top corner of the building was being photographed by one of his workers, and when the image was displayed on the digital camera it showed a column of mist located near the door of the caravan. It certainly wasn't there when the picture had been taken and being a digital camera, the image, of course, is instant. The caravan was devoid of any mist or anything else that could be seen and yet the picture on the camera's screen displayed this mist. A few pictures were taken and all with the same result. So what could be causing it? There doesn't seem to be an answer. The camera is in perfect working order

and the area around the caravan was quite clear. It left those who had witnessed bemused rather than frightened, but it is a mystery nonetheless.

The Gwyn Hall

One of the most iconic buildings in the town, the Gwyn Hall was built in 1887 on land gifted to the town by the wealthy landowner Howell Gwyn. The building was primarily a theatre venue, but was used for other purposes too. It was where the civic business of the town was carried out, until the 1960s when the original Civic Centre was built on the town's 'Bird in Hand Field', also known as the 'Old Fairfield'. Its attendant rooms were used by a variety of organisations to hold meetings, etc., and Neath Museum was also housed there.

In November 1889 the widow of Howell Gwyn gifted an organ to the hall. In the September of that year a statue of Howell Gwyn was unveiled outside the hall and remained there until 1967, when it was removed to Victoria Gardens.

While refurbishment work was being carried out on the hall in October 2007 a fire ripped through the building, leaving only a few walls standing. Immediately following the fire our city fathers announced that the hall would be rebuilt.

Harriet Eaton is the Neath Port Talbot County Borough Council's historian working out of the Neath Library. She was working as the relief caretaker at the Gwyn Hall in 2005. She had become familiar with the building prior to this appointment, through her involvement with local dramatic groups. She related to me the following:

> During the autumn of 2005 I was working at the Gwyn Hall as the relief caretaker while studying for my degree. Having been involved with the theatre for many years and in many roles I was aware of every nook, cranny and cupboard in the building, so locking up at the end of the night wasn't a problem to me and I had done so on numerous occasions without incident.
>
> On this particular weekend the stage crew for a local amateur operatic society were doing their 'get in', and it was my responsibility to walk through the entire building switching off lights, locking doors and making sure that I was the only person left before setting the alarms and leaving for the night.
>
> It was early on the Saturday evening that I said goodbye to the last of the crew, locking the front door behind them so that I could take my usual route through the building. Having checked the dressing rooms I ventured up to the stage, crossed the auditorium and switched off the lights at the back of the room. After descending the staircase at the rear of the building I stopped in my tracks as I heard the sound of children giggling at the top of

The Gwyn Hall.

the staircase. I looked up to see who was left in the building with the firm knowledge that I was the only mortal there. Seeing no one I quickly ran through the museum locking the doors behind me, grabbed my belongings, set the alarm and burst out of the side entrance into the dim October evening.

When I got home I asked my partner if he wouldn't mind coming to the theatre the following evening to help me lock up. I recounted the tale to my very sceptical boyfriend who raised his eyebrows, but said that he would assist if only to calm my nerves.

The following day I went to work and opened the theatre. The orchestra pit, microphones and public address system were all set up, the crew were working on the stage and the sound engineer had set up his equipment at the back of the auditorium. All was well and at about five o'clock I waved goodbye to the last of the crew and welcomed my partner with some relief to accompany me throughout the building to lock up.

Having walked through without incident I was just about to switch the auditorium lights off when my boyfriend asked where the music was coming from.

He was standing next to the stage, speakers and microphones, while I was at the back of the auditorium next to the sound desk. I hadn't switched the sound desk off as I was scared that I might wipe settings and upset the soundman, so I looked at the equaliser lights to find that there was nothing going into the desk and therefore nothing should be coming out of the speakers. Thinking that he was pulling my leg, I sauntered up to the stage with a wry smile. 'I'm not kidding you, it's coming from here' he exclaimed, pointing to the speaker.

As I approached the speaker I felt my skin go cold as I heard organ music quietly playing through it. 'I can hear it,' I said to him as calmly as I could, wanting to find an explanation. 'There must be something plugged in,' I added.

We scoured the orchestra pit but nothing was turned on or plugged in. I returned to the desk to seek an explanation. The CD player wasn't switched on and there was nothing of this world playing music through the speakers. I promptly switched off the sound desk, flicked off the lights and we hurriedly left the building with the music still being played through the speakers.

Walking to our home on Llantwit Road, my boyfriend asked why there would be old-fashioned organ music anyway and I explained that the area where we were standing was the site of the original organ, which had been removed many years previously.

The next morning I rang Jon, the Gwyn Hall's manager, asking him if I had locked up properly and set the alarms. I explained why and asked to have a word with the soundman in case I had missed anything. The soundman said that I hadn't. Everything had been in order.

> I firmly believe now that on that night my boyfriend and I were the very
> last people to ever hear the sound of the old Gwyn Hall organ.

The fire in 2007 would, if experts in supernatural behaviour are to be believed, have exorcised the hall of its hosts and spirits. Fire and/or flood are said to extinguish them. So the organ music heard on that autumn night in 2005 should not be heard again. And what of the sound of giggling children heard by Harriet on the night preceding the experience with the organ? They, too, should have been accounted for by the fire. But when the Gwyn Hall opens, having literally risen like the phoenix, and the gaiety of the town's dramatic groups echoes through and around this building, it wouldn't be surprising if the people of Neath's future come to relate stories about haunting spirits in this dominant place too.

Cadoxton Lodge

Cadoxton Lodge was located on the land now occupied by Stanley Place in Cadoxton. It was the home of the Tennant family, much revered in Neath's history. Members of the family were active in a variety of spheres, including industrial development (George Tennant built the Tennant Canal linking Aberdulais with Swansea), the arts, the literary world, journalism and exploration (Henry Morton Stanley – 'Doctor Livingstone, I presume' – was the husband of Dorothy Coombe-Tennant), law, Welsh culture, politics and even psychic research.

It is this last connection that interests us. Winifred Coombe-Tennant was the daughter of George Edward Pearce-Serocold and was born in 1874. She married Charles Coombe-Tennant in 1895 and they lived at Cadoxton Lodge. They went on to have four children: Christopher Serocold (*b.* 1897), Daphne (*b.* 1907, *d.* 1908), Alexander John Serocold (*b.* 1909) and Augustus Henry (*b.* 1913).

Her name is synonymous with good works, and she was involved in both political and cultural activities. She was the first woman to be appointed to the Glamorgan bench; the first woman appointed by the British Government as a delegate to the Assembly of the League of Nations; active in the Women's Movement and a candidate for the Liberal Party for the Forest of Dean in the election of 1922. She was an official visitor to Swansea Prison and succeeded in securing a change of policy to allow prisoners to use safety razors to shave; she became a member of the Gorsedd, taking the bardic name, Mam o Nedd, and was Mistress of the Robes. In the 1918 National Eisteddfod, held in Neath, she was chairman of the arts and crafts section. She was deputy chairman of the Women's Agricultural Committee for Neath & District during the Great War and chairman of the War Pensions Commission for Neath.

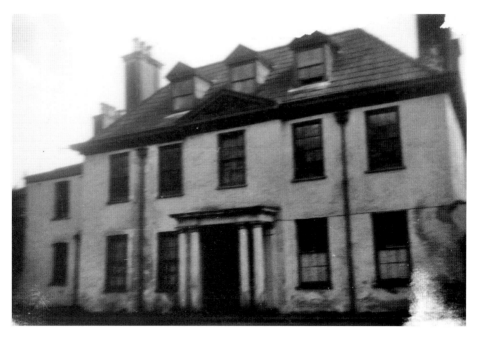

A somewhat blurred old photograph of Cadoxton Lodge, with its psychic connection.

In 1910 she joined a group of academics and psychics – her interest in spiritualism provoked, it is believed, by the death of her daughter, Daphne, in 1908. The family has a track record in this subject: her sister-in-law, Eveleen, had been married to F. W. H. Myers who together with H. Sidgwick had founded the Society for Psychic Research.

It transpired that Winifred was a talented medium, and she held séances and performed readings using the pseudonym Mrs Willett. Her apparent abilities to contact the other side were used by people of the stature of Gerald Balfour and Sir Oliver Lodge.

Her colourful life having crossed over into darker spiritual activities and interests may have affected her judgement, however. One rumour, which remains unproven, is that she and another member of her academic psychics' group, formed in 1910, made a decision to create, in the biblical sense, a Messiah or 'spirit-child' who would conquer all evil and deliver mankind to goodness and grace. The group weren't prepared to await another virgin birth. The consenting members, one of whom it is said was Winifred Coombe-Tennant (Mrs Willett), proceeded to reproduce, and the result was Augustus Henry in 1913.

All of this reckless behaviour had been provoked by the publication in 1859 of Charles Darwin's *On the Origin of Species*, together with the continuing anguish of the debate about eternity, life after death, and the frailties and failings of man.

Augustus Henry is generally known in Neath's local history by his second name only. It is unlikely that he was ever aware of his assumed destiny, and equally unlikely that he ever questioned his paternity. But oddly enough there was something of a religious bent in his life, although it didn't strive to save mankind. Following his public school education he went to Cambridge, then became a soldier in the Welsh Guards. He later joined MI6, where one of his colleagues was the traitor, Kim Philby. Following his conversion to Roman Catholicism, Augustus Henry passed away into eternity as a monk at Downside Abbey.

The adventurous and colourful Winifred Coombe-Tennant, a trusted friend of the great and powerful in the land, would probably have held readings and séances at Cadoxton Lodge and would have been disappointed if the odd ghost had not made contact. She died at the end of August 1956 in London. In September of that year a memorial service was held at All Saints by the Tower.

Cadoxton Lodge had been empty for some years when I crept in through the front door sometime in 1960. The door was ajar and the windows broken, the place forlorn, dark and dirty, its glory days only alive in the history books. I crept up the stairs for curiosity's sake, the dampness engulfing and peeling the paper from the walls. As I reached the landing I looked into the first room I came to; there was nothing but floorboards. Suddenly a window slammed down, although I hadn't seen one open, with a force that shattered the glass and seemed to echo throughout the building.

I knew nothing then of the Coombe-Tennant family. I was merely an inquisitive child, and knew nothing about the spiritualist Mrs Willett. But that window, on reflection, should not have moved without some physical encouragement. It did and it caused me to run blindly down the stairs and out of the door.

Perhaps a guest had responded to Mrs Willett's calling and hadn't left?

The Old Lady of Penrhiwtyn Manor House

Gerald Williams of Westbourne Road told the strange story of the ghost of the old lady of Penrhiwtyn manor house. This house was absorbed into what was Neath General Hospital before that was demolished, the land to be replaced by a housing site.

Gerald said:

As children we were told never to play in the grounds of the hospital or the old gipsy woman would take us away.

The story goes that the vision of the old lady had been seen near the old manor house, some said that she was an old gipsy woman who had been begging for food at the manor but had been cruelly rejected and turned away empty handed and that she later died nearby.

Despite being told not to play in the grounds we did. I do recall once being frightened by a glimpse of a vision of a woman with long, black hair flowing below her hat, her face wrinkled and her lips almost touching her nose, her eyes narrow through pain – pain caused by hunger? Her shawl, dirty and grimy, covered her black dress which flounced around her ankles. Scared? Yes, we were children and we ran.

One wonders if she still begs for food on the streets of the new estate. Is this the tragic secret behind the sighting of the mysterious old lady seen dressed in an old shawl and ragged dress?

Waunceirch, Bryncoch

This area of Bryncoch is a new development. Work started in the late 1990s and continued well into the 2000s. Ghostly activity is normally associated with older properties, but more modern buildings do play host to active spirits. There are a few older houses on the periphery of this area. One, Waunceirch House, was occupied at the beginning of the 1900s by relatives of the Price family of Neath Abbey – the family who worked the Neath Abbey Iron & Coal Company. This family left the house because of the industrial activity, which belched smoke and fumes and created noise and a plethora of dirty buildings associated with the coal-mining activity just below the house. They emigrated to Australia.

The ghost or ghosts in this case are something like half a mile from this old house, and, indeed linked with a new build, so one can reasonably conclude that the ghost's attachment is not property-based. Perhaps it is linked in some way to an unsuspecting individual living there, or even to someone who had visited and the ghost got left behind? We don't know.

But Helen Edwards, who had resided there, was certainly frightened by something that habitually banged doors and certain objects that would move from one place to another.

One morning, Mrs Edwards lay awake in bed contemplating what she had planned for the day. Dawn was breaking and everything was peaceful, when suddenly the bedside cabinet moved in an aggressive manner towards the bedroom door. She watched it, unable to move. Suddenly the open door slammed shut as though something was stopping the cabinet from leaving the room. The cabinet only stopped moving when it rested against the now-closed door.

She had become used to banging doors and so on, but this activity was too much to tolerate. She told her husband that it was time to leave. The strange happenings could get more bizarre and she didn't want to experience any further disruption to their lives.

Waunceirch housing development.

Her husband had an interest in spiritualism and had visited a medium who informed him that one of their grandfathers – Mrs Edwards didn't know if it was one of her or her husband's forebears – was trying to leave them a message. What that message was no one knows. Was the author of the message trying to make a contact by moving bedside cabinets and slamming doors? Mrs Edwards didn't stay in the house to find out. But was it the house that was haunted or possibly one of the occupants? Tellingly, no strange or unexplained behaviour has been reported in the house by subsequent occupiers.

Briton Ferry

Clive Mason, now living in Blaengwrach in the Vale of Neath, told me about a strange sighting of an old woman in the vicinity of St Mary's Close in Briton Ferry. Clive said that the houses in this close were built some time in the 1970s and are located near both the old Wern Works canteen and the site of Vernon House.

Both Clive and his wife hadn't long moved into the house in St Mary's Close when he was asked by a neighbour if he had seen 'the old woman'? He said that he hadn't.

Some time later, the question forgotten, he rose one morning to go to work and thought he saw the image of an old woman in the bedroom looking at him. He rubbed his eyes and continued dressing and left for work. Clive takes up the story:

When I returned home my mother asked me if I had gone into her bedroom before leaving that morning. I said I hadn't, and she replied, 'I thought I saw the door opening and then closing. I heard you shutting the front door on your way out.'

A few weeks later the old woman appeared again in my bedroom. This time my wife saw her, too, and was petrified.

The night after this sighting my young son, who had been suffering with a nasty cough, said that he thought his grandmother had come into the room in the middle of the night and had said to him, 'it's getting better now', and had pulled the covers over him and tucked him up nice and warm.

His grandmother said she hadn't stirred that night. My son's cough, which had been worrying us, cleared up completely a few days later. The old woman had been right.

Old Briton Ferry.

Other people in the area had said that they had seen this old woman, always a shadowy figure and always at a distance. We moved from there some time later.

An old woman concerned about the ailing son; did she, in some past life, work to look after the ill people who were housed at Vernon House? She certainly didn't harbour ill-feeling, and it seems that her only interest was expressing a concern for those who were not well.

The Windsor Cinema

The Windsor Cinema stood on the junction of Windsor Road and the Ropewalk. It is now demolished and the site is occupied by a housing association development.

For many years it was a Mecca for movie buffs, those who enjoyed the occasional film and for courting couples. Later it became a night club. Few people living in the Neath area up to the early years of the twenty-first century can have failed to cross its threshold at least once or twice in their lives. Like all venues of its kind it was atmospheric, helped, of course, by the dim lights, the hushed voices and the anticipation of an enjoyable few hours. Little wonder that they develop stories of unseen beings, strange noises, and shadows that appear and then mysteriously vanish leaving those who have witnessed them quite frightened.

Such was the experience of one of the usherettes from the halcyon days of the big movies. Betty Morris worked at the cinema in the early 1950s and told me about an incident that still causes her to sleep with the bedroom light on sometimes.

It was my first job. I worked in the ticket booth at first, which was located in the foyer, but after a few weeks I was asked to work as the usherette. This work entailed showing filmgoers to their seats, shining a torch along the rows, etc. The lights were generally dimmed before the films started; it only went completely dark as the projector began to roll. The lights were partially put on during the intervals and the auditorium was fully lit up at the end, usually following the playing of the national anthem. I soon got used to walking up and down the steep slope, avoiding tripping on the small steps, became adept at using the torch to assist me and the people finding their seats.

The type of film being shown – and there were normally two films at every sitting – dictated the age group of the filmgoers. You could predict if you would have middle-aged people, teenagers or children based on what was on offer. The weekday evening and Saturday screenings were for adults; Saturday

The site of the Windsor Cinema, now a housing complex.

mornings were the children's matinees. On a Saturday, no matter what was being shown, we would have the well-known back row filled with teenage courting couples. They were never a problem really; yes they could get a little over amorous sometimes, but usually a quiet word was enough to make them behave.

I remember it was the last week in April 1951 and I was showing people to their seats for the evening film, I directed a couple to their seats in the middle block towards the back of the seating area. I said to the couple, 'there, numbers 18 and 19.' I shone the torch along for them and they hurried along the narrows row then the woman turned as she reached number 18 and said to me, 'there is someone in the seat, miss.'

Because of the nature of the job I could usually remember where the gaps were and which lines were not filled. I flashed my torch across the row and the woman was correct; there was someone in the seat and more people sitting in the next three seats after that. I apologised and told them to take 16 and 17 instead. They settled and I continued with my duties.

After the lights dimmed and the film started I sat in my usual place right at the back waiting for the interval. I was still intrigued about those four seats in row G and could see the backs of the four people sitting in seats 18 to 21. There seemed nothing out of the ordinary about them, but I couldn't remember showing them to the seats.

The interval came and they remained sitting. Some people moved about, buying ice cream or going to the toilets and then finding their own way back. After the national anthem had been played the cinemagoers all filed out, with the exception of the four people, all male, sitting in row G. I went down towards them and asked them if they were ready to go. They didn't look at me but the rose to their feet and came towards me. One was smoking. I moved back to the centre of the aisle to enable them enough room to turn and go up the slope towards the exit. And then it happened: the first man, or should I say youth, anyway a teenager, didn't turn to pass in front of me but came directly towards me and seemed to pass right through me. I was shocked and caught my breath; the next one simply vanished in front of me as did the other two. By this time the auditorium was empty. I suddenly became frightened and called to John, the manager, who was near the doorway leading to the foyer or as we called it 'in front of house'. He looked in through the door and asked me what I wanted.

'Did you see four boys pass you?'

He said that he hadn't and that he thought everyone had left the building.

I tried to pull myself together – remember I was just fifteen years old. I looked up and down the seating area and there was no one to be seen. As I turned to walk up the slope and make my way to the foyer I smelt the strong, pungent aroma of cigarette tobacco. Not the stale smell of tobacco left behind the cinema goers; also a coldness seemed to engulf me, despite the

auditorium being very warm, which it would be after hundreds of people had been watching a film for at least two hours, sitting in close proximity. No, this was an icy cold, and a cloud of tobacco smoke that was so strong it made me cough.

At that moment John called out telling me to hurry up, and hurry up I did – I ran!

I did continue working there for a few months after that but soon left and got a job in Maypole in the centre of Neath.

I have remained convinced that I saw some ghosts that night in the cinema. Why would I not see them walk up the slope? How did one walk through me and the other three just vanish in front of me? And that icy coldness and the smell of fresh cigarette tobacco. I'm in my late seventies now and have never experienced anything else like it.

The cinema is gone now but I wonder if the ghosts of those four teenagers still linger on the site?

Darren Court, Longford

Hywel Davies told me the following story about an experience he had in Darren Court in his late teens. Hywel lived in the Highlands area of Neath Abbey from 1940 to the mid-1960s.

Darren Court was built in 1840 by Elijah Waring, author of the epitaph on the Murder Stone in Cadoxton Churchyard, and friend and correspondent of Iolo Morgannwg (Edward Williams, said to be the architect of the modern National Eisteddfod) and Robert Southey (Poet Laureate 1813–43). Waring was the brother-in-law of Joseph Tregelles Price, the Neath Abbey iron master, marrying his sister Deborah Price.

I was familiar with Darren Court. As children we often walked and played on the Drummau Mountain and would walk near the commodious house, which was then hidden in trees. I had left home in about 1951/52 to work in the Metal Box factory near Worcester, and returned to my parent's place in the Highlands about fifteen years later to stay for a few months before leaving to work in South Africa. I had started my working life in the Neath factory of Metal Box as an engineer and one of the ways to progress into management in the company was to take a posting to one of the factories abroad. I was still single then so this was an ideal and exciting move for me.

As I said, when we were kids we walked past Darren Court, and the house was always in shadow, both from the high coniferous trees and from its location in the lee of the mountain. We always had the feeling as we passed it that the old, grey stones of the building would tell us 'you do not belong

The gateway of Darren Court, where the spectral coach and horses were seen.

here, do not touch'. We always made sure we were not seen. At that time the house was, I think, owned by the Neath solicitor Windsor Williams. I had a sense of affection for the building because from my bedroom window at my parents' house I could always see, at night, the pencil point of light glinting through the trees. One of the first things I did following my return home while awaiting my trip to South Africa was to walk some my haunts from childhood, the first one was past Darren Court and then on to the top of the mountain, to see again the views across the Bristol Channel, to the north the Brecon Beacons and to the west the Carmarthen Fans; and, of course, the immediate sights of Skewen, dominated by the oil works in Llandarcy, Neath, Bryncoch and Longford. Part of the Longford housing estate had been built, but most of it was still a work in progress.

As I neared Darren Court I was surprised to find it empty – so much so that the front door was open. I ventured closer and peered in. There were still remnants of furniture and a metal spiral staircase, which interested me – I was a metalworker – in the far corner of the hallway. I went no further, though. I had no right, and the last thing I wanted was aggravation from someone who might be around. I carried on through the woods and forgot about the house.

It was late November and my posting to South Africa was due in the first week of January. A few nights after my walk, I glanced out of the bedroom window and was surprised to see that same pencil point of light I used to see years before emanating from Darren Court. I told my mother that the place was empty. She didn't know that and wasn't interested.

The following evening the small point of light was again visible. I decided to walk up to investigate. I would only go so far. I thought I'd go slowly through Darren Farm until I came to the fence, which would afford me a clear view of the back of the house, where I'd found the door open.

I grabbed a good torch, a stout walking stick, I wrapped up in an old greatcoat, bob hat pulled down over my ears. I told my mother I was going to see if I could find some foxes and she said I was mad, but I set off, her words ringing in my ears.

It was raining gently but this felt worse because of the wind that had whipped up. I reached Darren Farm in no time and turned my torch off as I quietly made my way through the yard. Once clear I switched it on and the beam picked out the small gate that led into the court. The path was made of red ash, which was a waste product from the copper smelting industry that once plied its trade in Neath Abbey put to good use as a base for paths throughout the area. The path twisted a few times before reaching the forecourt of the house. It was just past eleven o'clock. The rain and wind were still present, and the lights from both the farm and the houses where now lost to my sight as I glanced behind me.

I edged nearer and there was indeed light spilling from the big house. There was also the sound of music, not loud, but of a gentle orchestral nature. There were no people to be seen outside the house, but why I thought there might be I don't know. What was happening? I was beginning to think that I hadn't seen the place empty and desolate with the door open.

I switched my torch off and walked near the edge of the forecourt; I was partially hidden by the trees, until I was directly in front of the main door, which was open.

I quickly ran towards the house and pressed my back against the building. I could hear the music, could see the lights through a chink in the curtains (a few days ago when I had walked up here there were no curtains on the windows). I went closer to the door, stepped inside the hallway, and slowly eased open the door of the room where the music was coming from. I was confronted by a scene that resembled a Victorian ball: couples danced, the ladies dressed in wonderful full-length gowns, the gentlemen in immaculate evening wear. I watched transfixed. Then I stupidly knocked over a vase holding some dead flowers. It clattered and smashed, and immediately the place fell into complete darkness, accompanied by a most eerie silence. The suddenness of the change from a scene of gaiety to utter blackness was unnerving. I ran to the door and into the night, stopped in the middle of the forecourt and looked back at the

house. I shone my torch. The place was desolate, windows curtain-less, and a dankness enveloped the entire area. For a brief second the moon glinted through a rent in the cloud and threw light onto the gabled roof, and then everything was in total darkness.

I decided not to go home through the farm, the way I'd come. I felt the need to be among houses and people. With fear gripping me I ran down the long, gravelled drive that led me past the Darren Colliery. I could just make out the white five-bar gate at the bottom, marking the boundary of this desolate place, when I heard the sound of horses coming towards me and a voice clearly urging them forward: 'Git up, git up.'

'What now?' I thought, although this was tinged with relief that others were out on this night. Nevertheless I jumped into the hedge and waited. I could see the light bobbing behind the horses as they approached the gate, and I saw them more clearly, as the moon again dashed past broken cloud. The horses were pulling a carriage, and they went straight through the white gate as though it wasn't there. There were four horses trotting majestically towards me, the driver wearing a top hat and holding a long driving whip.

I remained still and hidden in the hedge as it went past me. I couldn't believe it. First I'd seen the house with lights on in a drawing room and people dancing and now this.

I stepped out from my hiding place and saw the carriage as it turned at the top and disappear from my sight onto the house's forecourt. I continued my way down the drive and touched the gate. It was solid enough. A ghostly set of horses! And I hadn't believed in such things ... until now.

I climbed the gate, paused as I put my leg over the top bar and looked back to the house. The lights shone in the window again. I ran down to the Longford estate and kept running until I reached home.

I confess I didn't sleep at all that night but tossed and turned. The following morning my mother made toast and asked me if I'd seen any foxes. No, I said, no foxes, but plenty of nightlife.

Hywel told me that he had gone through the events of that night many, many times, and on occasions even doubted what he'd seen. He said he had been near the place since and it was lived in and looked a happy place. His experiences that night remain a mystery.

Darren Court has been in the ownership of several people since it was first built. On the Drummau Mountain, on an approximate line with the house, is a geological fault line. On the Drummau you can easily see the splitting of the land, it is like the mountain is breaking in half.

Above Darren Court is a sheer rock face that dislodges huge boulders, probably because of the fault. They crash to the ground with a noise like thunder. One wonders if this geological disturbance causes a supernatural

reaction that results in a negative image being stamped on the house, so that it re-enacts past times, as though a video has been switched on, when the fault line is active and disturbs more rock creating some electrical force. It could be, but how are the carriage and the horses to be explained?

Streets & Roads

Victoria Gardens

The imposing line of late Victorian and early Edwardian houses, overlooking the peaceful haven of Victoria Gardens, stand sentinel in the town. Mostly gabled with attic windows, they all display an air of dominance.

This following was related to me by Helen Edwards' father, Clive Mason. Recently married, Helen and her spouse rented a flat in 1995 not far from the junction of Victoria Gardens and Cimla Road.

The strange activities in the house included cups involuntarily swinging to and fro on their hooks and then inexplicably falling to the ground. Or they wouldn't fall, but instead would merely swing slower and slower until they became motionless. For no reason pictures would fall from the secure hooks or nails on the wall, and curtains would move when there was no draft or reason for them to billow out. It was all quite unnerving.

A tall figure would be seen in the hallway during both the day and the night, always accompanied by a feeling of dread, fear and menace that would envelope the entire area, including those who saw it. The couple knew little about the history of the house or its surrounding area, but a neighbour revealed that the place had been the site of a murder some years previously. Helen and her spouse did not feel the need to try and release the spirit or understand the reasons for its presence. They moved out.

Haunted Bridge, Bryncoch

The bridge in question is located just below the junction of Tyn-yr-Heol Road. It is typical of thousands of similar structures dating back to the mid- to late

The road to Fireman's Hill, approaching the bridge over the River Clydach.

nineteenth century. Underneath it the River Clydach flows, winding its way from its source on Mynydd March Hywel, past this bridge and on to Cwm Clydach Reservoir, then to Neath Abbey village and into the River Neath.

The late Elizabeth Mort of Longford Farm, who lived latterly in Wernddu, drew my attention to this subject many years ago, and a few people have confirmed that they, too, have experienced the unease. Many people have told me about unusual sounds and feeling clammy, even on a summer's evening, both on the bridge and when approaching it from either direction.

The late Mr Cyril Davies lived for many years in one of the cottages at Cwm Clydach, the dwellings about 50 yards from the bridge. He related to me that often when he couldn't sleep at night he would take his small dog for a stroll. 'I only tried to walk her over the bridge once,' he said. 'She became fretful and distressed, stopping and trying to pull back and being awkward. She never usually did this and even when I picked her up, and I often used to carry her, she struggled. I never thought too much about it but there is a coldness in that area, whether it is because the river flows under the bridge at that point I don't know, but whatever, my dog didn't like it there. After that I walked up the road when she was with me.'

Horse riders have also said that often, but not all the time, when approaching the bridge their mounts become agitated and their gait moves uncomfortably

between a walk and a trot. Sometimes they throw their heads around and try to turn round, making their riders think that the horse is going to try and run away. I have experienced this myself while riding my daughter's pony Cennen Gambler back in the early 1980s. He would sometimes become awkward crossing the bridge, never refusing or trying to turn around, but on occasions rushing past it for no apparent reason. He didn't behave in this way at this site all the time, only occasionally.

But back to the late Cyril Davies, who was well-read and knowledgeable on many subjects. He told me that there had been a tragic accident at Boomerang Lodge, which is just below the bridge in the 1950s. A little girl drowned one night in the river and her body was found just below the bridge, caught up in the detritus in the water.

Mr Davies would shake his head and say, 'whether animals can sense the aftermath of that event, I don't know but for months, even years, the sadness of that tragedy was almost tangible in the air.'

Just behind the area that Boomerang Lodge occupies was the site of the Fire Engine Pit, which closed in the first half of the twentieth century. In all collieries there were fatal accidents, and this pit was no exception. The accident at the Main Colliery, Bryncoch, was particularly nasty.

The following is from David Rhys Phillips's *History of the Vale of Neath*, published in 1925:

Pwll Mawr was sunk for the Quakers by William Kirkhouse, the engineer and canal constructor sometime after 1806 and was said to be the first deep pit (200 yards) put down in this country. The 'drowning' of the Bryncoch colliery at 11 a.m., 6 April 1859 is still spoken of with awe by the elderly miners of the district. Eighty men and boys were employed there at the time. In one or two headings boring towards the Fire Engine pit was carried on, no one suspecting the presence of much water. But suddenly at the above hour the old working was pierced and water began to flow into the colliery like a river. There was but one way out – for the boring had been undertaken with the purpose of providing an up-cast on the Fire Engine side – and all but twenty-five men managed to escape; the rest were overwhelmed by the flood which ultimately rose over 80 feet in the drift. Some horses were saved and two others saved themselves by leaping into the descending trams and were drawn up in time. A boy escaped by clinging to the tail of one of these horses. The place was even then called the Main Colliery and the owners were named as Fox, Redwood & Co., a Quaker company.

Considering the locale and the link with the Fire Engine pit, which would have experienced some of the tragedy of the 1859 accident, the unrelated colliery accident of the little girl drowning in the River Clydach nearly a hundred years later, maybe some animals are picking up a sense of haunting. As Mr Davies

said when referring to the little girl, 'the sadness of that tragedy was almost tangible in the air.' Maybe it's still being detected and consequently displayed in the behaviour of our dogs and horses.

Jersey Lil

Old pictures of the *camera obscura* in Jersey Marine depict that the water's edge lapped against the lower levels of the small hill below the edifice built by Evan Evans. The site is better known now as the Tower Hotel and the land has been reclaimed in front of it with a dual carriageway linking Neath to Swansea.

The haunting by the character called Jersey Lil has been recorded on a section of Fabian Way from opposite the Tower and the old Ford's factory. Little is known about who she was. Motorists have occasionally reported seeing her only for her to disappear in front of them; others have said '[she] rushed into the road and we were fearful of a collision, but on the expected impact there was nothing there and nothing to be seen...'

Jersey Lil has haunted this stretch of road for the past forty years; indeed not long after the road's construction reports about her began to filter into the local newspapers. She has also been seen in the factory, too, though not now for quite some years. The old Fords of Swansea has had several incarnations since that company left the area, and whether our Jersey Lil associated herself in some way with the company isn't known. In recent years little has been reported about her.

The Old Town Hall, Church Place

Now called the Old Town Hall, the building in Church Place, Neath, is first mentioned in the minutes of the council (Hall Day Minute Book 1819–29) on 19 February 1819, when it was agreed that the Guildhall, which stood in Old Market Street (in those days this street was called High Street) should be replaced in its civic functions by the new building. The Guildhall spanned the road, with the offices being above allowing traffic, horses, carts and people to pass underneath it. The council was also agreed that the new town hall should be built on the site of another building at the junction of Church Place and New Street. It was felt that the Guildhall was inadequate for civic business to be carried out there and that the new hall should be of suitable dimensions and character befitting the town. The council allocated £1,000 towards the building and asked local business to help with donations.

In April 1819 the council signed a contract with W. Bowen, builders of Swansea, and twelve months later a contract was signed by a Mr Pliner to paint the hall and the market house.

Church Place.

Mention of the market house is important because the council had decided to use the lower part of the building to sell corn together with other items. This would provide a regular income from the rent, etc. The rooms above the market house would be used for meetings, court hearings and other aspects of civic business.

On 22 June 1820 the foundation stone was laid. A directory published in 1843 described the building as 'a neat commodious edifice in the Grecian style'.

As well as the upper rooms of the building being used for civic and legal business, a reading room was established where people could read local and national newspapers, free of any charge. This was a revolutionary idea because most of the people living in the town could not read – for the most part, only upper classes would have received the necessary education. The fact that a reading room was made available indicates a degree of foresight.

In 1834 the idea was mooted for a new market to be built in the town. By 1837 Neath market was established in the same position that it occupies today. This made the corn market aspect of the town hall redundant and the space left by the corn market was used for a variety of purposes, including as a fire station and cells. Today there are shops there.

The foundation stone was laid for the Gwyn Hall in 1887 and it was opened in 1899 aspects of local administration were held there together with civic work, which was still being carried out in the town hall. As time progressed and with more space and room being available in the Gwyn Hall much of Neath's council work was transferred there. But not all of it: local administration had changed and late in the nineteenth century a county council system had been created. With Neath Borough Council and Neath Rural District Council and the Neath Town Council to be accommodated, a lot of office space was needed. This continues to this day with the Old Town Hall in Church Place being administered by Neath Town Council.

The area around Church Place is arguably one of the oldest in the town. Nearby is St Thomas' church; in Church Place is the Mechanics' Institute, a reminder to us of Alfred Russel Wallace's activity in the town; and there is the St Ives public house, so named because of the trading links between Neath and Cornwall in the late eighteenth and early nineteenth centuries. So it wasn't a surprise to hear that a strange little man has been seen walking (or moving) from the Old Town Hall to the corner with Wind Street.

Betty Stokes was taking a short cut at about 5.30 p.m. in October last year, walking up from the Morrison's store and into New Street, then into Church Place. Just after she had passed the Old Town Hall, a figure came out of St Thomas's church gate and moved in front of her. This figure was of a man going in the same direction as her but only his legs and upper body were visible: his feet seemed to be lost in the ground. The road in this area, together with several roads in the immediate vicinity, has been re-laid with pavers and they

are very neat and ordered. The man was about 5 feet 5 inches in height and was dressed in typical Victorian or Edwardian clothes: top hat, neat dark suit, waistcoat with a watch chain, all covered by a dark greatcoat. Betty stopped and watched him. There was no one else walking nearby. He moved quickly until he came to the building next to the St Ives public house and opened the door and disappeared inside. Betty stressed that the door was opened, though you might have expected a ghost to just walk straight through it.

Betty hurried on up the street and paused by the door he'd disappeared through. The building was used by a firm of solicitors. The firm has been resident in Neath for years. 'I don't know what I saw,' said Betty. 'All I know is that I couldn't see his feet, but his action was like he was walking. His clothes, too, were not like those you'd see worn today.' Betty shrugged, 'I think it was a ghost. Maybe a dead solicitor who had business in the town hall or the church, who knows.'

The Old Man of Queen Street

This story has a similarity to the one featuring Church Place, where an old man is seen walking down the street towards the market. In this case, though, he is dressed in dark working clothes, wearing a flat cap and a cravat roughly caught around his neck. He moves slowly, clearly unhurried. His feet and lower legs are unseen as they are below the level of the road. Consequently his gait seems to glide along until he turns sharply as he passes the jeweller's shop on his right and disappears into the wall. Notably, it seems that he can be seen by some people and not others.

This was the experience described to me by a Mr Rees Robinson who was in the town shopping with his wife. It was nearly midday on a Saturday morning and the couple were both window shopping and calling in to some shops such as those featuring the various charities that have popped up in Neath, as they have in most other British towns and cities. They wandered towards the market. The street was quite busy, and it was a typical balmy late August day. Mr Robinson caught sight of the strange person walking about 20 yards in front of the couple. They were halfway down the street, but Mr Robinson said that he hadn't noticed him before as they walked along.

'I caught sight of him quite suddenly,' said Mr Robinson who, together with his wife, had lived in Briton Ferry for most of his seventy years. He continued:

> He was walking, or should I say moving, slowly, his head looking from side to side. Only later did I realise that other people walked past him without looking at him. Normally, if someone is dressed strangely or acting in a bizarre fashion people naturally look at him or her, and you can see them

Queen Street.

doing this. This chap was very close to people sometimes and no one seemed to see him. The fact that his lower legs were below the surface of the road, struck me as being odd. I know that saying that now seems daft, but at the time I seemed to be looking at his upper body.

Then when he passed the jewellery shop he turned and went through the wall. I said to my wife, 'did you see that chap?'

'What chap?' She asked. I quickly described him and was amazed that she said she hadn't seen anything odd.

I hurried to the point where he had disappeared, and as I thought, there was a brick wall there – between the jewellery shop and Marks & Spencer. I just stared at the wall – so much so that people who were passing were staring at me. My wife got somewhat impatient with me and urged me to move on. 'People are looking at you,' she said.

I had heard about this sighting before on Queen Street, many years ago, and the description was very similar. A short man wearing a flat cap – the original story was that his cap was worn at an angle on his head – a cravat and dark working clothes, together with a white shirt and a waistcoat. These are typically fashionable clothes for a working man from about 1880s to 1910. This person, too, had disappeared at the same place as Mr Robinson described.

I asked Mr Robinson how he felt about seeing this phenomenon. 'I believe I have seen a ghost,' he said. I nodded, agreeing with him. 'At least you believe me,' he added. 'Some people I've told this story to think I'm mad, daft or both. And every time I'm in Queen Street I'm looking for him.'

I explained to Mr Robinson that there used to be a footpath or a right of way in the exact place where the wall stands, through which our ghost disappeared. I remember my father taking me along the footpath in about 1950. There was a jeweller's there then and so was Marks & Spencer. This path separating them led to the back of the Gwyn Hall and out onto Orchard Street. I was young, but can clearly remember this path, and on the occasion I'm referring to as we neared the Gwyn Hall there were several dozen memorial headstones leaning against the hall's back wall. I had asked my father what they were and he had told me they were the headstones that once adorned Maes-yr-Haf chapel graveyard before they built the Parade and developed the adjacent area. 'The council will move them one day to Llanwit Cemetery,' he said.

So was our ghostly friend making his way along this footpath as he had done probably hundreds of times in his life? Was he making his way to the Gwyn Hall? Or was he searching for a grave memorial, which at this time was in transit from its original resting place?

Mr Robinson mentioned the fact that the ghost had no visible legs. I suggested that the build up of the road surface over the years accounted for this fact. As he walked in his time his feet were then firmly on the ground. Now they were lost in Tarmacadam.

As we parted he said that he had been glad he'd phoned me asking to meet. 'At least you believe me,' he said. 'You don't think I daft or losing my marbles.'

'You are not the first person to have seen our ghostly friend on Queen Street,' I replied, and added as we parted, 'I wish I could see him.'

The Stranger

The following story came to me third hand, told to me by a good friend of mine, the late John Blackmore, who had a passing interest in ghosts and the spirit world. He had heard the tale from someone who lived in Crynant but was courting a girl in Cilfrew. The romance was played out, as in so many instances, by the man walking to the next village to ply his troth.

The road between Cilfrew and Crynant is narrow, edged on the left by the 1,000-foot Mynydd March Hywel (the Mountain of Hywel's Stallion) and on the right, below in the *cwm*, by the rushing waters of the River Dulais. This is a lonely road, in the daytime, quiet save for the sound of birdsong, the babbling waters below and the occasional sound from one of the farms. At night it is shadowy and, if you let your imagination wander, malevolent, with the sounds of nightlife spooking you to walk quickly or run. The road is reminiscent of

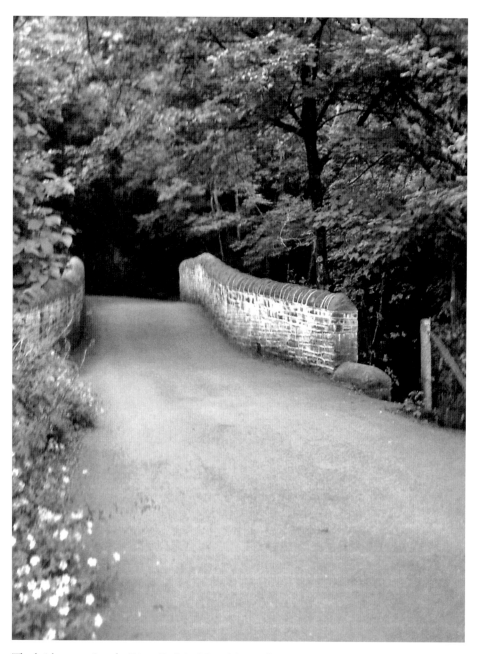

The bridge crossing the River Dulais, Maes Mawr, Crynant.

those described so wonderfully in the books of Richard Vaughan: *Moulded in Earth*, *Son of Justin* and *Who Rideth So Wild*.

John told me that in the 1960s he met a man in the Red Lion in Crynant who related to him the following story:

'You are going back on the old road?' he asked me referring to the road from the village back to Cilfrew. I said I was, but by car.

He said:

You want to try walking it. It will frighten the life out of you as it did me when I was courting the wife before the war.

It was a December time, a week or so before Christmas and everywhere was in good heart with plenty of revelry. I spent a few hours in the wife's house and the snow had started. Her father said I'd better get going because I had 5 or 6 miles to walk home.

When I got outside not only was it snowing but a wind had picked up as well. I set off walking up the hill, passing Tabor Chapel on my left. The gravestones already had a white top, and they seemed to be watching me – not a very good send-off when you had a long, winding, creepy road ahead of you. Coupled with that you passed the site of a tenth-century battle, hence the place names in the area that commemorated a Welsh king's son called Hywel who died in the conflict: March Hywel, Gelli March, Bryn Rhos and Bryn Bedd. There's plenty to worry about with each step.

Once you pass the chapel you leave the village behind. After that there are only the pinpoints of light that emanate from the various farms, but on a night in deep winter they offer no encouragement that human company is relatively close by. I tried to stop my mind from remembering the stories told to me by my grandfather about the fairy folk, the *Tylwyth Teg*, and the terrifying corpse candle carriers that appeared suddenly from nowhere, proclaiming a coming death. I remember lighting a Woodbine, trying to hunch further into my greatcoat and focus only on the road.

I must have walked about a mile when I came to a downhill part of the road that also had a sharp bend. I had started to whistle to help convince me and whoever or whatever that I was in a confident mood, when quite suddenly from the ditch on the right I heard the sound of a deep moaning. My hair bristled and goosebumps covered my body. I stopped walking. The only light was from my fag. The sound came again, mixed with the noise of the wind whipping through the trees. The snow didn't help my vision either, and I peered trying to see where the sound was coming from. At the same time I was ready to run either back to Cilfrew or on towards home and Crynant – whichever way didn't bother me, I just didn't want to be there.

Then there was movement from the ditch and a man, about my own height, older and wearing clothes that weren't really suitable for the weather, said

'Give us a tug. Give us a pull out.' I grabbed hold of him and hauled him from the brambles on to the road.

He rubbed his head and said that he had missed the sharp turn and walked straight off the road into the ditch. 'You must be freezing,' I said, but he responded by saying that he wasn't, and now that he was back on the road he was alright. His voice was deep and the whole time I was with him I never saw his features clearly.

I asked him which way he was going. He told me the same way as you. It didn't strike me as odd at the time, but how did he know which way I had been walking? However, we continued towards Crynant. I did feel better walking in company, and the silly fears about goblins, death candles and fairies all left me. We walked quickly, too, considering the snow on the road. It had started to ease and ahead and to our right as the moon poked through a rent in the clouds I could just make out the silhouette shape of the winding gear of Cefn Coed Colliery.

'What's your name?' I asked him. 'They call me old Dan Penybont,' he said. He didn't ask me my name and I didn't tell him. We were making good time now, walking quickly with little or no conversation. We past Ty'n-y-Graig and headed up the hill to the junction that led off to the left towards Gelli Galed Farm, where Howell Harris, the Methodist preacher, once gave a sermon, and then down the steep hill towards the bridge that crossed the angry River Dulais. Then we were on Maes Mawr Road and heading to the village and home.

I slipped as we crossed the bridge and lurched towards the wall. As I did so my balance went, and I nearly fell over it and into the swirling water. The man grabbed me by the arm and then I felt his other arm around my waist and he hauled me upright and to safety. I was shaken and felt silly for falling.

'Thanks,' I said. He said nothing but kept on walking. I hurried after him, passing the abattoir, and from the glow of some lights from the houses he turned his head and smiled.

We reached the top of Maes Mawr and joined the Main Road, passing this pub [the Red Lion] and then past the church, until we came to my house. He stopped by the gate, but how did he know I lived there? 'This is where I live,' I said. He nodded and put his hand on the gate and opened it for me. I didn't touch the gate.

'There you are boy,' he said. 'Home safe now you are. Take care on that ol' road in future, Benny.'

I stepped onto the path to my house and turned around, but the old man had gone. I could see both up and down the road and there was no one out – no one anywhere. I went to close the gate and where the snow should have been disturbed by his hand there was nothing, no disturbance at all. Again I looked up and down the road – upwards, he should have walked. He said he was from Penybont, which is at the top end of the village, but the snow was

quite clear of footprints and it couldn't have been covered over because the snow had stopped. I looked down towards the pub and I could clearly see the footprints I had made, but they were the only ones that had made a print. Then it occurred to me that he had mentioned my name by the gate – I hadn't told him who I was. He also knew where I lived.

With these thought rushing through my mind I hurried indoors and went straight to bed.

The following day I asked my father if he'd ever heard of a man called Dan Penybont? He looked quizzically at me and said that a man of that name had fallen from the bridge at the bottom of Maes Mawr about twenty years ago. That would be about 1910. 'Why do you ask?'

I said, 'no reason. Someone mentioned him, that's all.'

John Blackmore went on to tell me that the telling of the story had intrigued him and that he'd had to buy him several pints during the time he had related the tale. John had been and remained convinced that old Dan Penybont had stopped the man falling into the river at the same place that Dan had gone over the bridge and died. As far as he knew the ghost still haunted that stretch of road, waiting to help others to make it safety home.

Public Houses

The Duke of Wellington, Old Market Street, Neath

This eighteenth-century public house was originally called the Butchers. The name was changed when Arthur Wellesley, the Duke of Wellington, became Prime Minister in 1828. The pub is located in Old Market Street, which was once called High Street. The Duke has a definite atmosphere, much of which is created by the low level of internal lighting. Today the business, owned by Tony Di Muzio, is given over to both established and aspirant musicians who ply their trade on a raised platform for a stage at the back of the pub; practice sessions are carried out in the cellar. The pub is open for business only on Friday and Saturday nights.

There has been activity of a supernatural nature experienced there for many years, but only Tony, it seems, has taken the trouble to record and research it. The ghost in this building is affectionately called the Captain. He frequents the bar, the toilets, and the cellar, and although seemingly at ease with the fact that he still occupies a place in the here and now, there have been instances of a more violent nature. Amazingly the Captain has been recorded on videotape and broadcast to the vast audience that tuned in to the BBC morning television programme fronted by Robert Kilroy-Silk in 1993.

This video confounded a variety of experts both in photography and by those who analyse supernatural behaviour. Clearly seen on the tape is the movement of an apparition in the bar that has proved very difficult to explain. Also caught on the same video is what appears to be a little girl sitting on a stool by the bar and swinging her legs. The latter is not so clear and is open to interpretation, but seeing the video is a chilling experience.

Tony Di Muzio seems quite at ease with the spooky happenings and willingly recounts the stories experienced by many of his patrons. One evening the

Duke of Wellington.

subject was being lightly discussed and one young man considered the tales with a degree of frivolity, which clearly annoyed maybe the Captain or some other entity. Our young man laughed at the stories. He then went to the toilet, which is located along a passage to the right of the raised decked area, set aside for musicians. The toilet was lit, as was the passage. The young man had been gone only a few minutes when he returned with blood streaming down his face. He was distraught and not without some fear: 'Something hit me,' he said, 'but there was nothing in the toilet. Something just bashed me in the face. It hit me twice. There was no sound.' The wound above his cheek was treated and our young man could offer no explanation about the attack. But the message was that whether you believe that the Captain haunts the Duke of Wellington or not, it does not pay to loudly deny his existence!

The enthusiasm with which the musicians practise their art in the dimly lit bar is obvious. Tony knows what sounds are popular with his clients and allows the musicians free rein. But perhaps the Captain, or possibly the little girl, has different taste. Was this the reason for the singer in one band having the microphone stand banged on his head?

As was normal the band was fully engrossed in exploiting the sounds and lyrics, with the singer moving backwards and forwards in rhythm to the music, microphone in hand, when, quite suddenly and unexpectedly, the stand lifted

up and deliberately bonked him on the head. Then, just as casually, the stand returned itself to its usual place. The poor singer was taken aback, as was everyone who happened to be watching, and could only say 'what was that, what happened ... ?'

It can't be explained, save to suggest that a wrong note possibly had annoyed one of the ghosts, who are prone to make their presence felt when something upsets them. Or maybe the Captain just likes making his celebrity status known!

The Dulais Rock Inn, Aberdulais

The surrounding area of this imposing inn has seen many incarnations. From being a centre for copper industry in the sixteenth and seventeenth centuries, it then changed to an area of tin working, with a grist mill and a tucking mill. Buildings were developed along the main road opposite the pub, only to be demolished in the late twentieth century to make way for the extension of the A465 Heads of the Valleys Road. Finally, the Aberdulais Falls area has been developed from a kind of wilderness in the late twentieth century to a

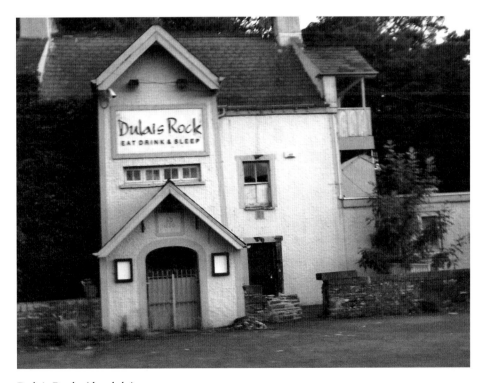

Dulais Rock, Aberdulais.

much-used tourist attraction under the stewardship of the National Trust today.

The inn dates from 1658, which makes it one of the oldest, if not the oldest hostelry in the Vale of Neath. Oliver Cromwell and his confidants are among the notables reputed to have visited the inn, mostly likely while on the way to or from Pembroke.

The inn's most recent incarnation was in 2010, when it ceased its life as a public house. It was purchased by Tony Di Muzio, who told me that his intention was to convert the building into a residence. He kindly showed me around the inn. Its cavernous rooms reach one to another on all the floors, but none more so than the cellar area, which contained the storage and cooking areas used during the days when the hostelry provided food as well as alcoholic refreshments.

The Juliet balconies afford views both up the road into the valley and towards the town. Tony expressed a fondness for them, so they will certainly not be disturbed should any refurbishments take place. Its days under the stewardship of the Evan Bevan Brewery in Cadoxton, one of nearly 200 inns that company once owned, and its time as a coaching inn offer many possibilities of lost souls, perhaps seeking their release to a greater place or merely happy to wander the thick stone-walled rooms and the shadowy cellar where dampness eases through the stone-slab floors.

The most recent landlady, who was busy clearing out her possessions when Tony was showing me around, expressed delight and relief that she and her spouse were leaving. Mentioning the subject of ghosts encouraged her to pack her clothes more hurriedly. 'I'm glad to be going,' she said. 'Not another night here, thank you.'

She explained that shadowy figures would often be seen from the corner of the eye, and when she turned around there would be nothing there, leaving her only with a sinister feeling. This was particularly felt in the passageway between the bar and the toilets. At night there was also the distinctive sound of the dumbwaiter, which operated on a pulley mechanism, moving up and down from the room adjacent to the main bar down to the kitchen in the cellar. But when checked, it clearly hadn't been moved for many years. She said:

> It freaked me out. Although I never saw anything, there was always this feeling that we were being watched by something that was decidedly unwelcoming. We didn't provide food, so the kitchen in the cellar wasn't being used and little time was spent down there, but the entire atmosphere in there is not nice.

Tony, the new owner, is quite unfazed by the past occupants' experiences. He smiled as we left and said 'this is going to be my pad'.

The Star, Penydre

The landlord, Mr Peter Rees, willingly described to me the supernatural happenings that had been felt in the Star. This inn is one of the oldest licensed hostelries in Neath. First mentioned in the late 1700s, it is believed to have been built partially from stones taken from the Neath Castle.

The haunting presence is said to be a lady, one Jane Thomas, who was born in the inn in 1865 and was the granddaughter of the landlord. Mr Rees said that he had not actually seen the ghost but he had felt a presence. He said:

> I have felt a hand on my back, and sometimes you get the feeling that someone is close to you. When I felt the hand on my back I was sitting in the room and I turned around quickly but there was no one there. I was sitting with my back to the wall so no one could have been behind me and there was no draft or a chill in the air.

Mr Rees's son said that he too had experienced an atmosphere and was convinced that there was something there.

Mr Rees continued saying that several of his regulars had seen a shadowy figure moving about in the bar. 'A previous landlord has seen her,' he said.

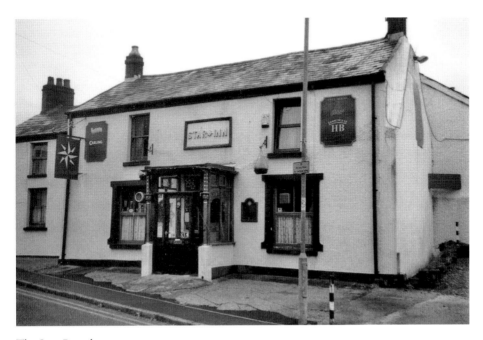

The Star, Penydre.

Other customers had seen it too; one claimed that when he had visited the toilet he saw a woman dressed in old fashioned clothes standing in the corner of the room. This person then said that the woman had walked through the wall.

Some locals have said that the ghost may not be Jane Thomas, as she didn't pass away on the premises. She died around 1897 and is buried in Swansea. Mr Rees added that instead there is speculation that the ghost is that of a woman who was murdered in a cottage next door to the inn.

Mr Rees is philosophical about the spirit:

Many locals have talked about this story for years, long before my time here. But whether it is Jane Thomas trying to rekindle either a happy or a sad childhood, or the ghost of a murdered lady who lived close by, I don't have a problem with it. I'm happy to share the place with her.

The Castle Hotel

Many of this hotel's hauntings have been documented in previous publications. The most prominent hostelry in the town, and one of the oldest, it dominates the Parade with an air of well-kept elegance, and it is the place where most celebrities and VIPs will stay when visiting Neath. At various periods in its history it has been known as the Ship & Castle Inn, the Castle Inn and now, of course, the Castle Hotel. It is, too, arguably the town's most haunted building.

Early records tell us that it was built in 1695, but unnamed and trading under the landlord's name, which was Proffs. It has been the focus for many events, important meetings, seminars, etc. In 1699 Sir Edward Mansel dined there after visiting the Melyncrythan Works. In 1784 the Gnoll Masonic Lodge 'removed to the Ship and Castle Inn'; the landlord then was William Meyrick, who was also a mason. In 1786 Charles Nott, the father of Major- General Sir William Nott who was in charge of the defence of Candahar in 1842, became its landlord. Sir William Nott's birthdate coincides with his father's tenure of the inn. Charles Nott left Neath in 1796 for the Ivy Bush in Carmarthen.

In 1796 Lewis Roterley took over the management of the inn but after only four years he left for the Mackworth Arms in Swansea. Like his predecessor he had a prominent son: Major Lewis Roterley was Lieutenant of Marines on the *Cleopatra* at Martinique in 1808.

From 1789 the trustees of the Neath Turnpike Trust held their meetings at the inn; also, the auction for the letting of the toll-gates was held there. From 1792 until 1808 it was the venue of the committee briefed with the rebuilding of the Neath River Bridge. Lord Nelson and Lady Hamilton are said to have frequented the inn on a number of occasion; in more recent times Richard

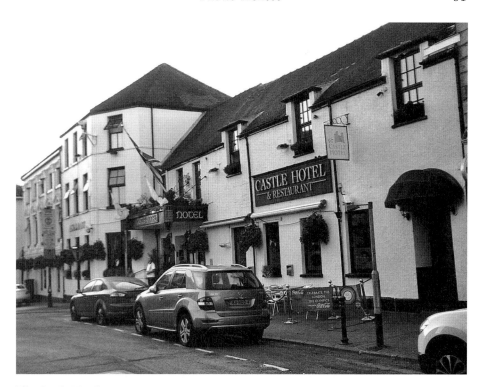

The Castle Hotel.

Burton and Elizabeth Taylor were guests. Also, it was in the Nelson Room in 1881 that the Welsh Rugby Union was formed.

In around 1845 a wager was made at the Castle Hotel by Captain Frederick Fredericks of Dyffryn that he could fire a revolver through a mirror without breaking it except for the hole the bullet would make. This wager was won by the Captain and the mirror was a feature in the Nelson Room until it was lost some years ago during a refurbishment.

The Castle was the principal stopping place and change over for the mail coach travelling from London to Milford; coaches also left bound for Swansea, Merthyr, Brecon and Gloucester. The large area used as coach houses and stabling was behind the Parade, now used as a car park and an array of small businesses. The sound of horses' shod hooves on the cobbled yards and the clanging of blacksmiths' hammers would have been constant.

The current proprietor's son, Mr James Rees, has recorded several strange happenings following discussion with Mr Darrel Jeremiah, a former general manager of the hotel. One of these is the story of the baying hound.

The sound of a baying hound has been heard at various times over the years. The sounds, both mournful and aggressive, emanate from the cellars, which are used for the storage of various items that are needed for the smooth running of the business. This cavernous area is painted white, has large heating pipes

running near the ceiling, and has several rooms and passageways, one of which leads to a bricked-up archway. Intriguingly, no one seems to know what is located on the other side of the arch, but clearly years ago it went somewhere and for some purpose. Mr James Rees said it had always been bricked up during the time his family had owned the hotel. A suggestion to remove some of the bricks to satisfy a curiosity was laughed aside by James: 'It leads in the direction of the River Neath. We'll leave well alone; goodness knows what we'll find!'

But it is from this general location that the sounds of the baying hound are heard. Did the tunnel once give access to the river? If so, was the purpose to smuggle illicit liquor from the ships that berthed at the wharf downriver from the bridge? Did the smugglers, in a hurry and with the customs men in hot pursuit, leave their faithful hound to roam the area between the river and the hotel for eternity? We'll never know. But as James Rees said, with a shrug of his shoulders, 'Who knows, but as long as he stays down here in the cellar and doesn't climb the stairs we'll be happy.' Maybe one day, eons into the future, someone might excavate the passageway and find the rotting bones of our canine friend.

Another recent sighting of a ghost in the Castle Hotel was by bar manager Amanda Llewellyn. She walked into the lounge and busied herself clearing glasses. Turning she saw, standing by the bar, the figure of a man dressed in a tunic with silver-coloured buttons down the front. He wore dark clothes and sported a black beard. He was looking at her and as she continued turning her immediate response was to apologise to him for walking into the room without acknowledging him. Amanda continued:

I said, 'Sorry, I didn't see you there. And then in front of me he disappeared. I wasn't spooked, just shocked. He wasn't threatening in any way; he just stood there as though he was waiting to get served.

When I mentioned this experience to other members some of them admitted they, too, had seen him. Before I started working here I'd heard that it was haunted but that didn't worry me, and it still doesn't, but now I know that this old place clearly has a past that many customers or staff will not let go off.

James Rees, the proprietor's son, went on to tell me about an incident that occurred recently concerning the telephone in the boardroom. This room is located on the first floor of the hotel and when the phone is being used in the room, as for the phones in all of the rooms, a light indicates its use at the reception desk.

One evening the light came on informing the receptionist that the phone was being used. James was near the desk and the receptionist asked him why the boardroom was being used at this time in the evening. He said it was not being

used and he had closed and locked the door himself only a short time ago. 'But the light is on,' she said.

James asked the security men to accompany him to the room and even as they hurried up the stairs the phone light remained on. Within less than half a minute they arrived at the door and sure enough, as James had said, it was locked. The security man unlocked it and the door was thrust open. It was in complete darkness, the phone resting in its cradle. Then, suddenly, a distinct gust of wind blew past them before an eerie stillness descended. Almost together, they asked, 'What was that?'

They couldn't explain it. There was certainly no one in the room, yet the record of the phone's use in that room at that precise time indicated that it been in use. Unfortunately the phone record doesn't tell us who made the call or to whom, it just records that the line had been active. And the gust of wind?

The Rock & Fountain Inn, Ynysgollen, Aberdulais

The building is located on the B4242 running from Aberdulais to Glynneath and the hostelry was developed from three cottages dating from the late eighteenth century. The inn was developed by Evan Evans, the proprietor of the Vale of Neath Brewery in the early nineteenth century. It has continued as a public house, with the exception of a brief period in the late twentieth century when it was purchased by Pauline and John, who continued the business as a hostelry.

There is an interesting story about a thick, falling mist that enveloped the road near the inn. Peter Carey encountered it on his way to work and somehow 'lost' four hours of his life, apparently as a result. The mist, it seems, emanated from the inn, or at least whatever force guides or directs it seems to be centred on the inn.

Pauline told me that Nick, the inn's handyman, has had a similar experience, albeit not quite as dramatic as Peter's. Although the adjective 'dramatic' rather depends on who was caught up in this loss of time saga. Nick told me that he felt more beused than frightened by his experience, but at the same time the lack of understanding regarding the event leaves one with a sense or feeling of 'what was all that about?' Nick said:

> I'm usually the first person in work; I start soon after six in the morning and have a set routine. Tidying things away from the side of the building, mopping and brushing the passageway that leads from the outside side door right through to the bar and restaurant area.
>
> One morning I was busying myself and made my way from the side door to the bar, this is something I have done hundreds of times, but on the morning in question I entered the passageway and for some reason it was several minutes before I arrived in the bar.

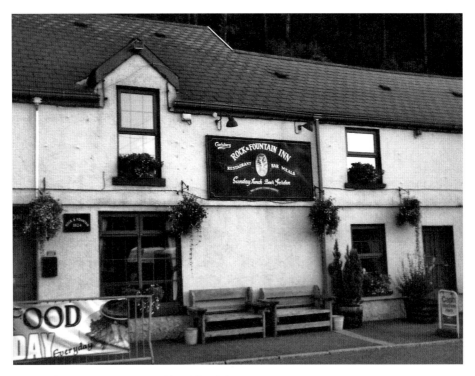

The Rock & Fountain, Ynysgollen, Aberdulais.

I paced the distance out from the door to the bar and it is only approximately 21 yards. You would cover that in a matter of seconds. Nick continued:

> I didn't feel anything at all, only when I did arrive in the bar I couldn't believe the time. I had lost several minutes. I know that doesn't sound much but at sixish in the morning, when the downstairs area is empty, I couldn't understand it. Looking back I don't think I felt any coldness, any pressure against me, nothing at all. But something happened to make me lose the time.
>
> I continue with my usual routine, the same jobs are carried out six days per week, I must have walked along the passageway literally hundreds of time since and have never had the same experience. That's what is intriguing. The question lingers with me about what did happen.
>
> I'm not feared or anything. I'm really comfortable working in the inn and like the periods when I'm alone to get on with my work. For a time after that incident I did tread carefully, shall we say. I thought about walking along the passage but never once have I stopped myself from doing so. Whatever is there certainly doesn't harm me or mean me any ill feeling. But it would be nice to know why.

Pauline told me that it is not unusual to hear the sound of footsteps late at night or during the early hours when the inn is closed. Pauline and John live upstairs, but have never ventured down at night to see if there is an intruder. 'Somehow that has never occurred to us,' she said. 'Yes we hear noises, and of course, the building creeks, all buildings creek and particularly when they are the best part of 300 years old, but the footfalls we hear both upstairs and downstairs and on the stairwell don't freak us out. Somehow they are a part of the place and we are used to them. Maybe whoever is responsible for them likes us being here.'

The loss of time story isn't an unusual form of haunting. There are many recorded stories but naturally none can be explained.

The Victoria Inn

The Victoria, in Commercial Street, was the public house that preceded the Dark Arch and has since been renamed The Arch. In 1983 the building was owned by the late Mr Mike Richards, and was renovated and renamed the Dark Arch.

Mr Richards had contracted with a Skewen joinery firm called the Wood Shop to make alterations to create a bar in an upstairs room in the pub. The landlord was keen that this work should be carried out during the night to cause as little disruption as possible to the ongoing business.

Peter Williams was, and still is, employed as a carpenter by the Wood Shop and was briefed with carrying out the work. Peter had no problem with working at night. Then he had no opinion about ghosts or hauntings and as a twenty-year-old would usually laugh about such stories. But that was soon to change.

The Victoria dates back to the nineteenth century and was, not unusually, named after Queen Victoria. Its location places it very near the old animal market, so it would have been frequented on market days by hundreds of farmers who gathered in the town to buy and sell their stock. It may also have been frequented by seafarers, employed on the ships that would have moored at the quays just below the Neath River Bridge. The pub was also used by the Catholic Church until 1868 to hold services. The priests used one of the upstairs rooms to conduct their Masses. The church moved after that date to what is now called the Moose Hall and stayed there until St Joseph's Church was opened in 1933.

Peter and a colleague soon got started on the work after the pub had closed and nothing happened on the first night to alarm them. They estimated the work would take a few nights.

The second night, at just after 2.30 a.m., Peter was alone in the upstairs room. His mate had gone to the van to pick up some tools, when suddenly the

temperature dropped dramatically, to such a degree that he started to shiver. He couldn't explain this as the weather was warm. But he continued working, his back to the bar that was under construction. There was a shelf holding a row of full bottles. The bottles started to rattle against each other, without falling off the shelf, creating quite a noise. Peter looked up, unable to believe his eyes. The temperature was by now icy cold and the noise got louder and louder. He just started at the bottles.

Peter continued:

> Then, strangely, from behind me or to my side, I can't say from where, there was a sort of muffled scream, as though you screamed into a handkerchief or a cloth. I moved to the door, turned and ran down the stairs. I was shaking, told my mate to get in van. I slammed the pub door and we left, quickly. I suppose, to use the cliché, I was white. Later that morning I told my boss about the experience and that I was not going back there during the night.

Peter's boss, was then, and is now; Brian Richards (no relation to Mike Richards the landlord). He got in touch with Mike and explained what had happened. The landlord was understanding, saying that previous contractors who had worked in the room had related a similar story. Mike went on to say that a seaman, lodging in the pub sometime during the late 1800s, had been robbed and murdered in that room.

Peter and his mate continued the renovations during the daytime and despite there being no further disruption to their work he said he was glad when the job was finished. And, defensively, he adds, 'I know what I saw.'

Following the Victoria Inn story I searched through reams of the Cambrian Newspaper published between 1802 and 1936, this newspaper was the first English language paper to be published in Wales and I came upon the following story.

The Market Tavern (PJ's Place)

The Market Tavern ceased being a public house in 2009, suffering the same fate as thousands of such businesses up and down the country because of the changes in social behaviour. The building was purchased in 2010 by Mr Paul Jenkins who has transformed the bar area into a pleasant and popular café. But ever since he bought the property he has experienced unexplained activity in the café, in some of the upstairs rooms and in the cellar.

I paid a visit to the café one afternoon and Paul described some of the unusual and seemingly strange occurrences: 'I was in the cellar one morning checking my stock,' explained Paul, 'I was alone in the building, but I heard the distinctive sound of someone walking in the shop.' Paul took me down into

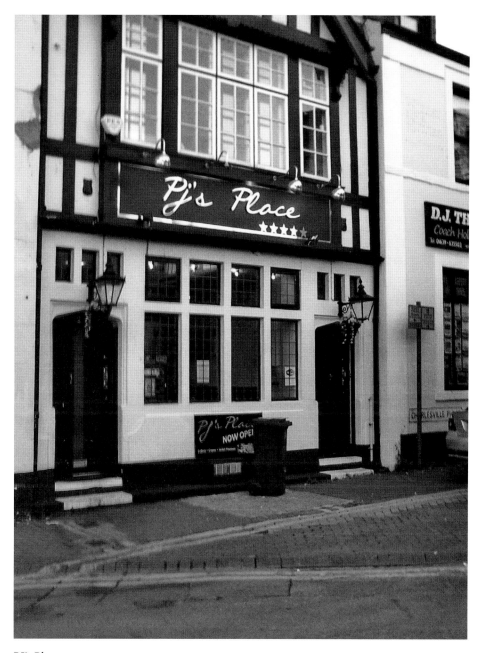

PJ's Place.

the cellar and we could hear the noise people made while walking around. 'Just like that,' he said. 'This cellar had passages leading off under the road and it is usually warm and clammy down here.'

The bricked-up passageways were indeed visible, leading off in opposite directions. It is impossible to say exactly where they once led, unless the blocked-up sections were removed and one tried to walk or crawl through them hoping to find some sort of conclusion. Paul's theory, and I concur with it, is that the passages, or at least one of them, led towards the Neath wharf and maybe were used to smuggle illicit goods to the old pub, much like the bricked-up passages or tunnels that run from the cellars in the Castle Hotel.

Paul told me that one morning he had come downstairs from the living quarters and found the door to the cellar open. He was the only person with a key to the cellar door and he clearly remembered locking it the previous night. He went down the concrete steps and found the room in a chaotic mess: wood had been thrown about, the boxes that contained the paper coffee cups were everywhere and the cups and lids scattered on the floor. More alarmingly, from an immediate fiscal aspect, he found that the freezer had been switched off and all its contents had thawed and were ruined.

Paul was clearly upset when he told me about the freezer, and it left us thinking that whatever had thrown the switch was clearly of a malicious nature.

He explained that at some time in the past the cellar had been used to keep dead bodies and coffins, presumably in readiness for burial, though why they were stored in the cellar of a pub isn't known.

Paul mentioned that there had been sightings of a small boy, dressed in what is thought to be Edwardian clothes, both in the café shop and upstairs. I was interested in this particular haunting because it matched the experience of a previous occupier of the Market Tavern who had related it to me more than thirty years ago. That landlord claimed to have seen a boy in the living room upstairs. He said he had seen it often and it didn't bother him. Paul confirmed this story, and added that there was also a small girl haunting the building. She has generally been seen in the café both behind the counter and in the public area. Paul said that a member of his staff had experienced the feeling that someone was holding her legs, but when she looked down there was nothing to be seen and the feeling left her.

Then Paul pointed to a table in the café and said:

I used to carry out some of my bookwork sitting at that table, and I also would read the newspaper. But what I found was that when I was sitting there things would kick off – bumps upstairs, shadows in the shop and one afternoon the lightbulbs exploded. I now sit at this table, he said, indicating one located at the end of the counter. Things are calmer here, though why I can't say.

He continued, relating other anecdotes he couldn't explain:

> One day I'd been to the bank [nearby] and I saw just the back of someone entering the café. I turned immediately to go in after the person to serve them but when I went into the café, literally a second later, there was no one there. This has happened a few times.

Following an invitation by Paul, a group called Spirit Rescue International has visited the café on a number of occasions to carry out investigations. This team is very experienced and did detect paranormal behaviour. Some was captured on film and has been taken away by the group for further analysis. 'Spirit International has removed some of the spooky things,' said Paul, 'But not everything. Noises are still heard in most of the rooms, door still open when there is no one there, the television jumps channels when no one is holding the remote and my computer can go funny. I didn't used to believe in ghosts and such like,' he added, 'but that was before I bought the café. Now I do; but the strange thing is that I have got used to it, in a way. Nothing has ever hurt us directly – though the switching off of the freezer did hurt indirectly – I intend on staying here. The ghosts are not going to frighten me off.'

Animal Hauntings

The Old English Sheepdog, Longford, Neath Abbey

A strange story that involves an Old English Sheepdog was related to me last year by Mr Madley from Longford, which has left him absolutely bemused, but not frightened. 'Indeed,' he said, 'it leaves me with some kind of warmth.' Mr Madley continued:

About twenty years ago I was given an Old English Sheepdog puppy that I adored. Everywhere I went he would accompany me and within the household he was very much my dog. No one else bothered with him; in fact no one in the house liked or got on with him. But he was my best friend and he reciprocated with total loyalty.

The family were always nagging me to get rid of him, he was big, cumbersome, knocked things over and when I wasn't there they said he growled at them. Added to all this, he moulted too.

I resisted the pleas to give him away for eight years until one day after a flaming row. The dog had wet in the living room, then run up the stairs and knocked over several vases containing both water and flowers. They crashed to the bottom, water and broken glass everywhere. And then the dog ran down the stairs, cutting his feet on the glass, which resulted in bloody paw prints all over the kitchen. There were ructions.

I relented and phoned a breeder of Old English sheepdogs in Ammanford and he agreed to take the dog. I admit, as I looked at him sitting proudly on the rear seat of the car, that I was tearful all the way to his new home. Once there I didn't hang around; I handed the new owner his lead and his papers and left immediately. Once back home I didn't speak to any member of the family for a fortnight.

I move on some twelve years, and by this time I had retired: a morning constitutional for me is to walk to the local shop and buy a paper and walk back home. A gentleman in his late seventies had moved in a few doors from us and kept himself to himself, with hardly a cursory nod offered when I would pass him coming from the shop. But one morning he acknowledged me:

'Morning,' he said. 'Where's your dog today?'

'What dog?' I asked. 'I haven't got one.'

He looked at me, quizzically. 'What do you mean? I see that Old English sheepdog walking behind you most mornings. He minds his own business, just plodding at your feet.'

And with that he passed by.

I walked home and wondered. It had been years since my old dog had been given away and I hadn't heard a word from the breeder since then. And what had that neighbour seen? No one else had ever commented about such a dog. I was always alone. Or do dogs have spirits can they become ghosts and return to affectionate owners after death? My new neighbour would have known nothing about my dog and yet he said he sees him with me.

This is not very frightening, much like many other animal haunting stories. Indeed. I've never come upon a scary one – except possibly the baying hounds story. Generally such hauntings give some sort of relief to those who have experienced them. The story of the white blackbird falls into this category.

The White Blackbird

This story is from the 1960s and happened in a chapel in the Vale of Neath. Like most weddings, Alice Jacob and David Rees's had been meticulously planned, and as is usual everyone was looking forward to the event. But two weeks before the date of the nuptials, the bride's father, Maurice, died from a heart attack. The family's attention was turned now from the forthcoming wedding to arranging a funeral.

There was talk of cancelling the couple's big day but the bride's mother said quite firmly that it would be the last thing her husband would have wanted. Thus the wedding followed the funeral by six days, although it was with tears that the couple and those present at the wedding passed Maurice's grave on the way into the chapel.

The service went by in something of a haze. Maurice's absence was naturally felt hugely by the bride; after all it was her father who should have given her away and that honour had passed to a close friend. Everyone tried hard to make the day memorable but it was difficult, until something happened that has remained with the family and everyone present ever since.

As the minister pronounced the couple man and wife there was a fluttering sound from the back of the chapel and a white blackbird flew in a circle near the high, decorated ceiling and then landed on the rail behind the couple. An albino blackbird is a rare thing; further it was identifiably a male because its beak was orange. Everyone was shocked and some were bemused as the bird balanced itself, with its tail going up and down. Its head shifting from side to side, it flew up and landed on the bride's shoulder, between the couple. She was transfixed and her new husband moved to push it away but it took off again, and then amazingly flew to the bride's mother and rested on the pew and then started to sing.

This went on for several seconds but felt like forever and throughout no one in the congregation moved or uttered a word.

The minster tried to move the service on and the bird took to the wing again and flew back to the bride and groom, alighting on the table in front of them that was adorned with flowers. Again it started singing and with that flew back to the bride's mother, paused on the pew, and then flew from the chapel.

The bird's actions had all seemed deliberate, contrived. It wasn't like the mad, fearful flying of a bird trapped in a building and trying to escape. This one seemed to know where it was and what it wanted to do.

Once it had gone the couple went into the chapel's vestry to sign the register and the people in the congregation all talked about the strange behaviour of the white blackbird. A few linked it to Maurice, but no one gave this any credence. The bride's mother cried quietly as she waited for the couple's return from the vestry.

It was a happier scene as the bride and groom walked into the sunlight outside the chapel, and as the rice and confetti was good naturedly thrown over them the distinctive tone of a blackbird was heard again. Everyone went quiet and looked behind them. Perched on Maurice's grave was the white blackbird, this time leaving no one in any doubt that whatever awaits us in the veil beyond this existence, there exist forces that we cannot explain.

Margam Crematorium

A similar story to that of the white blackbird happened at the funeral of a dear friend of mine in the 1990s. He had died in distressing circumstances in his mid-fifties; the funeral took place at Margam. He had been a pigeon fancier and a bird watcher for many years, as had his father before him. As with most people who pass on at a relatively young age, the service was packed with family, friends and colleagues. During the entire service a bird flew about in the chapel, causing not a little disturbance, and actually alighted on to the coffin. As the committal proceeded and the coffin dropped from view the bird disappeared, too.

No one present that I spoke to thought too much about it. The bird was a nuisance and nothing more. But on reflection was our friend, in his inimitable way, letting us know and announcing that his time had certainly come on this Earth, but a freer dominion lies ahead?

The Honey Bees

It is possible that animal behaviourists can explain this strange story of how a swarm of honey bees concentrated on the nectar contained in the flowers on a particular grave when, at Easter time, the cemetery's graves were adorned with hundreds of fresh flowers.

David Davies had been an enthusiastic beekeeper since his early twenties and when he died and was laid to rest in 1970 in his home village of Rhos, aged seventy-nine years, his funeral was attended by many of his like-minded apiarists.

Immediately following the grave-side service, people paused and paid their respects at the open grave then left. The grave diggers got to work filling in the grave and then laying the floral tributes tidily over the gently raised mound.

The two men were surprised to see a swarm of bees descend onto the floral tributes, while ignoring every other flower in the area. Soon hundreds of the insects covered the grave almost hiding the wreaths. At about the same time, the apiarist friend of David's was tending the deceased's hives in his garden when, to his amazement, the bees swarmed from the three hives and took off in the direction of the cemetery. The grave diggers said that after some fifteen minutes the bees rose as though receiving a signal and flew off. The bees had headed back to the hive where David's friend was still waiting.

Why didn't the bees seek nectar from the other flowers? Why only from the floral tributes on David's grave? Were they in some inexplicable way paying homage to the man who had looked after them so lovingly?

The Graves

The Terrified Policeman

This story was told to me recently following a talk I have given on Neath's haunted places to the Retired Police Officers' Association of Neath:

During the late 1950s there was a officer based at Skewen Police Station, who, not unlike many of his profession at that time, stood in excess of 6 feet in height, tolerated no nonsense from young people bent on mischief and had an even heavier hand, together with an unenviable store of local knowledge, towards those who were either career criminals or those of the more opportunist attitude to other people's property. This man was red-haired and Scottish by birth. A traditional, tough police officer, he feared little.

On the night shift his beat was to walk down New Road towards Neath Abbey Village, checking that all the doors of the various commercial properties were locked.

The only sounds in those days were of the traditional stop tap in public houses and the only fast food outlets were the fish and chip shops whose doors were closed at the latest by 10.00 p.m.; the younger revellers from the Ritz on Station Road and the more sedate members of the British Legion, at the top of Caenant Terrace, would all have cleared the streets by 11.30 p.m. The local copper made his way through the night and anyone abroad in the small hours would be challenged about why they were out – usually only young men hurrying home after courting.

The policeman would have continued about his business, always looking for something unusual, something out of place. His experienced eye would register everything and he would analyse it with his rapier mind. He would not be seen at the same time in the same place night after night but would

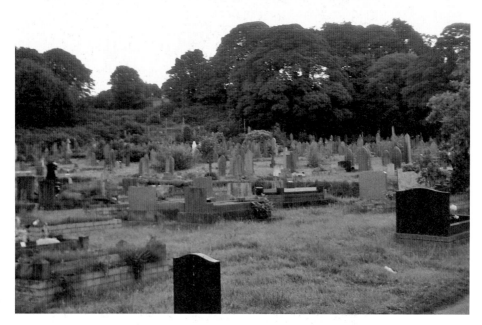

St John's Churchyard.

vary his beat, though terminating at a prescribed time with a colleague in Neath Abbey, where notes were exchanged.

Passing the imposing Gorffwysfa Chapel and opposite the paper shop he made his way towards White Gates, which afforded a crossing over the road for the mineral railway, which headed for Neath Abbey Wharf. Then his beat took him on to the Terminus Hotel. Usually everything was silent, occasionally emphasised by a fox exercising his own beat, and he would enter the graveyard of St John's church, opened in 1850, its sprawling lines of memorials offering testimonies to the dead of both Neath Abbey and Skewen.

He had always enjoyed the peace and certainly did not fear this or any place: he had been a copper for too long. He scanned the cemetery with his torch, moving the light around until it landed on the huge edifice of the church, which stood on slightly higher ground – everything seemed in order on this night. But then he caught a movement between the lines of graves. He stopped and directed the torch towards it; nothing. He was still not fazed and thought if it had been anything it was a rabbit, fox or a night bird. He moved on, slowly. His eyes scanned the area, his mind still suspicious about what he thought he had seen. This night the sky was covered by cloud, with no breeze.

His normal route was to walk towards the building and take a footpath that would link up with Hill Road and the Croft. As he neared the main entrance to the church the silence was broken by the rumbling and straining sound of a steam train pulling up the Skewen Bank. Seconds after the train had passed he began to walk up to the church, but stopped because walking towards him was a figure. Or not so much walking, but gliding. All of his experience of policing couldn't stop him from becoming frightened; his hand shook as he reached for his truncheon. He flashed the torch again and called out: 'Stop there! Police!' But the figure kept coming towards him. It was a grey colour with no discernable clothes or features. It came right up to him and walked through him. He felt a bitter coldness echo through his body. He started to shake uncontrollably as the figure kept walking towards the gate Despite the presence of a passing car going towards Skewen, the policeman was still rooted with fear.

As it neared the gate the figure turned, or seemed to, and came back towards him. He then ran in the opposite direction, his still-lit torch flashing in all directions and his truncheon held firmly in the other hand. He continued running past the graves that lined both sides of the footpath until he arrived on Hill Road. He paused briefly and half ran and half walked towards Neath Abbey village. It was there he met me, and his condition can only be described as shot through. He was sweating and couldn't speak with any sort of cohesion. He blurted his words, and all I caught was 'ghost' and 'the churchyard'.

We sat down on a roadside seat near Ty Mawr and I made him take a drink from the small flask of coffee I always carried with me on the night shift. He began to calm down.

He asked me how long I had known him. I told him it must have been ten years or so. 'Have I ever been like this before?' he asked me.

'No,' I replied, 'Never.'

After half an hour, which now made us late, he said he would walk back to the police station by keeping to the main road and would inform his sergeant about the episode. It was 2.30 a.m. when we parted. I walked back to Neath, puzzled.

He did indeed inform his superior about the night's events and told him that if his beat included the churchyard he would resign. Normally officialdom in the force doesn't tolerate such demands, but he was allowed to continue policing Skewen at night with the walk through the church taken out of the beat. The beat officer from Neath Abbey was made to detour to include it. Nothing like the spectre was seen by any other policeman.

There are many stories about ghosts in the Neath Abbey area, but they normally involve monks or something like them. Whatever frightened this copper some fifty years ago was never explained.

As an ironic aside, when the victim of this story passed away in the mid-1970s he was buried in St John's churchyard. One wonders if he then had opportunity to confront his tormentor.

A Cemetery in the Vale of Neath

My mother used to call me morbid, but I'm not, I'm just fascinated by graves, and, of course, those who occupy them. Speaking to sextons, gravediggers and people who generally look after churchyards and cemeteries is so very interesting. As a profession, one can generalise, they all care deeply about the work they do, which they carry out with absolute professionalism and respect. Something else about them: they love to talk about their work. And in some cases your appearance, as in the case of the sexton at St Michael & All Angels in Lingen, a village on the Welsh borders, who asked me why I hadn't cleaned my shoes. 'Always clean your shoes when you plan to come to a churchyard,' he said. He wasn't joking.

Early in the 1970s instruction was given to a sexton to open a grave in what was a congested area, with the graves so close they were sometimes touching. The grave had last been opened in 1907, and its new incumbent was to be a lady from Aberystwyth whose last request was that her body be returned to Neath and interned in the family's grave.

The digging began and the gravedigger soon found it was brick lined right to the top. Brick lining graves is an expensive process but it was very fashionable in the Victorian and Edwardian periods, and only the financially well off could afford it. Not only are the grave's sides lined with bricks, giving it a very neat and cared-for appearance, but slabs are then placed on top of the coffin, which is set down snugly into a cavity that is shaped in the same style as the coffin. Then the slabs sit over the coffin, protecting it from the earth. Arguably it makes the digging process easier for the gravedigger because he doesn't have to calculate to a fine degree where the coffin is – he certainly doesn't want his spade to smash into it, as he digs down making a space for the new one.

The digger soon came to the slabs, some 6 feet down, and was faced by an unusual sight: one of the slabs was edge down, cutting right into the coffin below. It had to be removed and with help the offending stone was pulled out. This caused the wood of the coffin to disintegrate leaving the skeleton visible. Its arms and hands were held forward from what had been the body, the hands pressed upwards, indicating, perhaps, that the poor soul had been buried alive. The gravedigger said:

> It was horrifying seeing broken coffins and the skeletal or fleshy remains of the dead is part of the work we do, but this sight threw up questions: had the person been buried alive and had tried to push the lid off the coffin or make

a sound to attract attention? Had the gravediggers, placing the slabs after the moaners had left, heard the sounds, panicked and bashed the slab sideways into the coffin to finish him off? Horrible thought.

Our friendly gravedigger, who was relating the story thirty or forty years after the event, was clearly still disturbed by what he had witnessed.

Respect from the Skies

Another strange story told to me by Mr Bishop, the sexton at Llantwit Cemetery, was about the internment of a man who had lived away from Neath for many years. He had seen service in the Second World War with the RAF and now his family were honouring his last wish that he should be laid to rest in the town of his birth. Mr Bishop said:

> It wasn't a big funeral, but a respectable number of family and friends together with representatives from the British Legion. The service at the graveside was brief, the initial one had taken place at the chapel of rest. At the point when the coffin was lowered into the ground three jet planes flying low from north to south appeared, and as they flew over the cemetery they suddenly accelerated and climbed at high speed disappearing from view in a matter of seconds. Many of us present where surprised and most couldn't help but look up, actually holding the coffin by the white ropes. In an instant composure was regained and the coffin and its occupant was laid to its eternal rest.

Was this just a coincidence or some act of a supernatural nature that was waving a last goodbye to a pilot colleague? Mr Bishop was perplexed but yet it was another of those strange or odd stories that can sometimes happen in graveyards.

Miscellaneous

Elidorus, Pontneddfechan

There are many stories about the fairy folk inhabiting the Vale of Neath. They all add to the romance of this scenic valley despite its industrial scars from the eighteenth and nineteenth centuries, many of which have now been eradicated and the areas laid back to nature. Writers like Iolo Morgannwg, Giraldus Cambrensis and more latterly David Rhys Phillips have thankfully documented these stories for us. The upper area of the Neath Valley, in and around the village of Pontneddfechan and delightfully called the Waterfall Country, has an array of such tales that reach back through the centuries.

The story of Elidorus was originally recorded in Latin during the latter years of the twelfth century by Giraldus Cambrensis, the son of a Norman baron and a Welsh princess. He heard the story while on a propaganda tour with Archbishop Baldwin in support of the Crusades, and recorded it for posterity in his *Itinerarium Cambriae*, or *Journey of Wales*. It is similar to the one about the Welshman who discovered the entrance to a cavern or cave below Craig-y-Ddinas that led to an underworld full of riches. The trouble was it was guarded by the sleeping knights of King Arthur. And although tricking the waking knights into returning to their sleep other forces prevented him from stealing the gold and other treasures.

Elidorus was a twelve-year-old lad whose intention it was to become a priest. His lack of intellect prevented him grasping information quickly and to encourage him to learn more quickly his teacher resorted to beating him, the aim to knock sense into him.

Understandably our hero ran away and hid in a hollow alongside the River Neath. After two or three days he became hungry and tired and was approached by two strange little men who promised the aspirant priest they would lead him to a land of pleasure and plenty.

They led him to the entrance to a cave and along many passages until they came upon an underground country. The people there were very small but extremely beautiful with fair complexions and long, silk-like golden hair.

Elidorus was welcomed to this country by the king and, after questioning him about his origins, he sent him to play with his son, who was about the same age. They played for many hours with a golden ball.

Sometime later he found his way back along the underground passage to the river bank and made his way home. He told his mother about his adventure and his encounter with the strange, friendly people, about the golden furniture and artefacts that dwelt in this twilight world.

He paid many visits to this world and one day as he left his home his mother asked him to bring her back a present of gold.

In the cavernous twilight world as he played with his friend, the king's son, he stole the golden orb and ran along the stony passageways away from the enchanted world.

As he approached the entrance he tripped and fell. Picking himself up, he was confronted by the two strange little men who had shown him the cave in the first place. They took the golden orb from him and sent him away in disgrace.

Many times he tried to find the gateway to the magical world below the Vale of Neath, but never succeeded. He returned to his teachers and did eventually become a priest.

The Silica Mine, Pontneddfechan

Quartzite or silica rock was mined at the head of the Vale of Neath from the late eighteenth century until 1964. The atmospheric silica mine still exists, although entry into it must be of an illicit nature. This fact does not seem to prevent people from exploring the remnants of the mine, which used the pillar-and-stall method, still evident at this site.

William Western Young was associated with the site; he developed a method of producing very high quality firebrick from this Dinas silica rock, which had a high melting point. The bricks were manufactured at the Pontwalby brickworks in Glyn Neath. This product was exported throughout the world and even today the Welsh word *dinas*, meaning firebrick, appears in the Russian dictionary.

In Wales we are familiar with the damage that mineral dust causes to the cardiovascular system in workmen. The managers and owners of the mine fired the stone at night to allow the dangerous dust to settle before the day's work began.

Today the aerial ropeway can still be seen. It was used to carry the mined and refined material down the valley. The remnant of a dilapidated dram

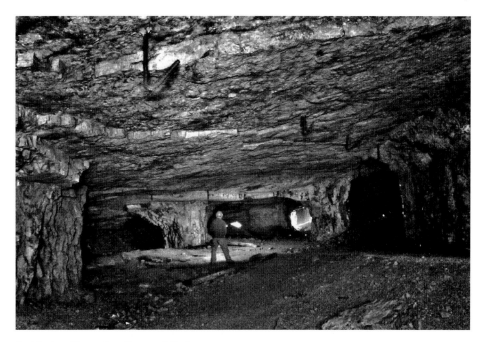

Inside the silica mine, Pontneddfechan.

crushed into the rugged rock face alone now sings the praises of a once-thriving enterprise.

I was fortunate enough to be in a party of archaeology enthusiasts to be taken into the mine in 2009, led by the irascible, knowledgeable, Barrie Flint. The blackness wasn't as dense as you'll find in a coal mine; nevertheless, several torches were needed to brighten our way and to keep our feet on stable ground.

The mine is full of atmosphere, but not of a threatening nature, and our small team clambered up to the different levels and negotiated the pools of water without mishap. Then, faintly, we heard the sound of muffled voices. Initially the goosebumps grew on our necks as in absolute silence we listened, trying to hear them more clearly. It was Barrie who led the way forward, 'Come on,' he whispered, 'this way.' We moved toward the sound, carefully feeling our way over the fallen stones and bent remnants of the old tram rails until we came to a junction. To the right the track fell steeply, and from there the voices were much clearer, emanating from below.

In our minds we were now embarking on a proper ghost hunt. There had been no sign of anyone else in the mine and the excitement and fear mingled as Barrie led the way apprehensively.

Despite my interest in all aspects of the supernatural I have never been involved in a ghost hunt or séance save for one occasion when I attended one as a historian in the Castle Hotel in Neath, which was conducted by the excellent medium, Austin Charles.

That event had been held between 10.00 p.m. and 6.00 a.m. and was uneventful, with no bangs or sudden movements in the shadows. But remarkably, many of the names thrown up about which I was asked for historical clarification were belonging to people who had played a prominent part in the hotel's past life. The whole experience makes you wonder. Austin Charles' behaviour was forthright with no dramatics or 'I think I heard' comments.

But now as we descended the passageway of the long-disused mine the voices grew stronger, our fear and goosebumps grew more pronounced, the beams from our torches bounced off the walls and the rough ground, and as we turned yet another corner into full view appeared two men dressed in wetsuits, fully equipped with diving apparel. They were as surprised to see us as we were to see them. Barrie, still in the lead, said 'Hello,' his voice without a quiver.

They were quite human; two members of a caving club from Gwent who were exploring the mine as we were, taking pictures for their archives. The ghost hunting was over. And we were relieved.

But don't write off the possibility that other beings from beyond this world lurking in the depths of the mine. Don't go there without adequate torches, as Barrie Flint did on occasion when he ventured there alone and his batteries failed. When asked how he managed, he brushed off the question by saying with a bit of luck and a lot of instinct.

Wenallt Ironworks, Cwmgwrach

Few acts of demolition are more dramatic or dangerous than when an industrial cooling stack or tower is razed to the ground, particularly when the method is to build a bonfire of wood and old vehicle tyres at its base and fire it. This method was enthusiastically demonstrated by the late Fred Dibna on the television programme that featured his work as a steeplejack and his consuming interest in steam-powered road vehicles. This method of demolishing the industrial stacks that once populated almost every village and town in urban Wales was naturally used to pull down the tower at the Wenallt Ironworks in Cwmgwrach.

Mr Alan King now living in Pwllfaron Cottage, Aberpergwm, told me about the event, which happened about 1971 or 1972 and attracted a large crowd to witness the drama.

A Mr William A. Slocombe had the contract to carry out the work and he had prepared the area around the stack well. Old railway sleepers and tyres made up the majority of the burning material and everyone was cautioned to stand well clear and this caution was well supervised, Alan told me.

We took pictures throughout the operation, and the one here clearly depicts a man standing at the base of the stack dressed in boots and overalls. The

odd thing about this is that this person, or whatever it was, certainly wasn't visible to the naked eye during the demolition work. It wouldn't have been possible, Mr Slocombe and his colleagues were very careful. The man in the picture only appeared in the shot after it was developed. He wasn't seen by anyone who was watching or was involved in the work. And if someone had managed to get into the position depicted in the photograph he would not have survived the fire or the falling masonry.

A strange happening indeed. The photograph is quite clear, there is a person there. In the aftermath of the demolition, no person was found to be injured, fatally or otherwise.

Christmas Day Angel

The following was told to me by Mrs Bethan Morgan, an experience she had while walking her dogs alongside the Neath Canal some ten years ago.

It was a bright, frosty and cold Christmas Day afternoon. My husband was cocooned in a Christmas dinner-induced coma, sleeping off the effects of too many roast potatoes followed by an overdose of chocolate cream gateaux. Being aware of how quickly it would get dark at this time of year I decided to take our three dogs out for their teatime walk. It had not been my intention to go far, as even though the sun sparkled on the sheets of ice on the frozen canal, the mist descended very quickly from the mountains. If you were not careful you could lose visibility.

One of the dogs, a sheepdog we had rescued only three weeks before, did not seem to feel the cold as he bounded along the path, leaving the other two terriers far behind. The dog had a mania for water and would swim along the length of the canal every day, much to the amusement of other dog walkers.

One of the terriers would run alongside him barking enthusiastically as though she was some form of canine swimming coach, while the older one looked at him in disgust, clearly regarding him as a show off, which indeed he was.

But this afternoon I did not want him in the water as the canal was frozen – not that this would put him off, but I did not want to wade in after him.

He ran on in front of us as though he hadn't been out for days; he just never seemed to tire. All the while I called his name followed by a stern 'no' every time he sneakily tried to slide into the water. Further down the canal we came to a stretch of the canal that had not frozen and before I could stop him he had launched himself in, with one of the terriers barking furiously on the edge of the bank.

I decided to let him have a quick swim and then turn around and head for home as it was getting colder. It was about half past three but the sun was already starting to set, like a huge glowing ball as it hovered over the mountain. I called him to me. He was satisfied; he'd had his daily swim and he would want to get home to be dried in a great big warm towel.

He'd swum over to the bank on the opposite side of the canal and even though he was a strong dog and a powerful swimmer – he didn't seem to be moving, he seemed to be treading water.

I called him again with more urgency in my voice. One of the terriers began barking frantically and suddenly with horror I realised his tail was caught in some brambles on the opposite bank.

The canal was too deep for me to get to him. I was not a swimmer and am afraid of water. If I could have got to him I did not know how I could have untangled him. By now he was getting panicky as he was trying to swim toward me to free himself but he was also getting tired and the water was cold.

I kept calling his name, amid shouts of 'good boy, you can do it,' but I knew he was in trouble, and so were all of us. It was Christmas afternoon, four o'clock by now, but for the fact it had been a sunny day, it would have been dark. Most sensible people were engaged in alcoholic slumbers or feasting on yet another round of sherry trifle, ensconced in front of the telly and the ubiquitous Christmas Day airing of *The Great Escape*. So why was I still out at the mercy of this crazy bounding bundle of energy, when if it had just been the two terriers and me, we'd have been out and back in half an hour.

We hadn't seen one single person, walker, cyclist or dog walker, and this was in the days before mobile phones. We had rescued this dog just a month ago. The victim of a marital break-up he arrived in to our lives out of the blue one December night. The alternative, it would seem, was the great kennel in the sky.

As a family we are ardent animal lovers, and various bundles of fur and hair just turn up. Over the years at the various houses in our family circle animals ranging from rabbits to horses have been welcomed into the mix so it had been with the errant sheepdog; he was just absorbed in to our household with the two terriers and the cat.

I could not believe he could not use his strength to pull himself away from the brambles. Even though we were not far from home, by the time I could have run back with the two little terriers I knew it would be too late. I was at the stretch of canal where there were no houses and it was again just that bit too far to the next village to get help. I was rooted to the spot and my heart was hammering at the thought that I would see this beautiful animal, who I had fallen in love with, drown before my eyes as I stood helplessly on the bank.

My black terrier continued to bark as though her lungs would burst, and by now I was crying hysterically, shouting his name and pleading with him to try harder to free himself. All the while the sun was sinking, everywhere was silent and nothing moved. I thought I was on the verge of a heart attack and was so frightened. I knew I would never forgive myself if he died but there was nothing I could do. He was too far away from me and the water was beginning to freeze and it was too deep.

The dog was tiring by now and my terrier was barking as hysterically as I was screaming.

Suddenly I shouted 'Oh God, please help me, don't let this happen.'

Moments later I saw a man walking slowly, casually down the canal path. I waved in panic. He continued walking slowly, which began to annoy me. I have a problem here, hurry, I thought. As he got closer I could see he was small in stature and of slim build.

My immediate thought was to ask him to stay with my two terriers while I ran as fast as I could up the canal path, across the stone bridge and on to the main road from there I would be behind the bank where my dog was trapped but the there was a wire fence I would have to wrestle with, but with my mind racing and being hysterical, it was all I could think of. I could have reached him from the opposite bank.

He eventually came within yards of me, and while normally I would have been cautious of a man walking alone at dusk on the canal path, this was not the time to be concerned with my safety. Besides which I would not normally be on the path with the dogs at this time of day.

He asked me quite calmly and casually 'What's the matter, love?'

Amid sobs I screamed that my dog was drowning as he was caught in the brambles, I pointed at the dog whose struggling was weaker. And just as I was about to launch in to my hysterical request to hold my dogs while I ran up the path and onto the road, which I now know would have been too late, he held up his hand to quieten me. He told me he made walking sticks and that he was always out looking for wood with which to fashion them. He then pulled something out from his inside pocket, which he said fortunately he always carried with him. Before my eyes he unfolded a fold-up machete, in the same way you might unfurl a pen knife.

In an instant, two things went through my mind. Firstly I never knew such a thing as a fold-up machete existed; and secondly, Christmas Day, freezing cold, deserted village and canal path, a lone man out walking and carrying a fold-up weapon comes across hysterical middle-aged woman with three dogs, one of whom is trapped in freezing water. I could just see the newspaper headlines.

Talk about your life flashing before you, I felt that this might be my end. This was it. I was a firm believer in a God that is merciful and loving, who has protected me all, my life and seen me through much trouble and turmoil,

yet He ignores my frenzied cry for help and allows the mad axe man to do whatever horrors he has in store for me and maybe after making fur from their coats make stew with the rest of them. And worst of all, my husband probably sleeps on in sweet oblivion and will never get over this horrible tragedy. We have many more years ahead of us and God, it wasn't supposed to end like this.

The 'mad axe man', who I was by now convinced would be the topic of the post Christmas press headlines 'Christmas Day Canal Murder', calmly began to hack down a branch from a tree, which I thought he would club me to death with. He explained he was going to throw it across the canal at the brambles and hopefully it would break the tangle and the dog would swim free. He added it might hit him on the head, but he would try to aim for the bush behind his tail. So if he didn't drown, he would be knocked out by a bang on the head. What next? I thought.

I knew I had to trust this man, but I think I would have done the dance of the seven veils if I thought it would have saved my poor struggling and by now frightened dog. His face was in the water and he was tired of struggling and if I am honest I did not think his plan would work.

What I needed was a 6-foot, 20-stone hulk who could have just walked in to the water freed my dog, said 'Okay now, love?' then gone on his way, leaving me to get myself and dogs back to the warmth and safety of home. Instead I had a 7-stone potential axe maniac who might be pretending to help me rescue my dog, while planning a 'Christmas Day Massacre'.

After he had chopped down a large branch, during which I wanted to scream at him 'faster man, my dog is drowning', he calmly stood at the edge of the bank and carefully took aim. He hurled the branch at the other side of the bank at the spot where the dog was entangled in the bramble bush. I covered my eyes as I thought the branch would land on his head and send him under the water bringing about his death anyway. The next thing I knew my newfound friend calmly said, 'There we are boy, all right now?'

The dog was freed from the brambles with the man's first throw, and promptly swam across the canal, climbed out shook himself vigorously and shot off up the canal path. I was rooted to the spot and still didn't know what would happen next.

I began to thank him between crying and telling him how I had rescued the dog and how I thought I was losing him and the effect on my two little terriers and on and on while struggling for breath and by now hysterical in an euphoric sense of relief. All the while my rescuer was so calm and at no time did he talk to me to try to calm me down or tell me it would be all right or even ask me where I lived or anything really.

He merely smiled, nodded his head and walked off. I turned and hurried in the opposite direction, my sheepdog was sitting on the tow path about 50 yards ahead, waiting.

As we, the dogs and I, were on the last stretch of canal path and nearly home, I saw the man again walking towards us, I couldn't work this out, he had set off in the opposite direction. I was still crying, but this time with relief. It was almost dark now and as he passed me I thanked him but he didn't seem to want to talk to me or acknowledge the fact I needed to thank him. He had passed me and strangely the three dogs whined and became very submissive. Ignoring the fact that I couldn't understand how he was there I asked him where he lived, and the following day I would have had my husband drive us there to thank him and ask if there was anything we could do to repay his kindness? Without turning around he said, 'Go home now.'

When we eventually got home it was five o'clock .We hadn't been far but we had been gone for two hours. As the dogs and I scrambled through the back door and the safety of the house I could scarce believe what had happened.

The noise and exuberance of the dogs woke my husband from his fireside slumber. Oblivious to the time, he just thought we had come back from a quick teatime short walk. 'Been far?' He asked. I could not answer him as I was still trying to compose myself. I towelled the sheepdog furiously as my husband declared he should not have gone in the canal as it was too cold for him.

I eventually told him the whole story and I could see him trying to make sense of it all while at the same time trying to bring himself out of his fireside rest. I could not blame him although I did inform him somewhat acidly that while he slept, I could have been battling with a murderer who was out looking for lonely women walking their dogs on a deserted canal path on a Christmas day as their husbands were snoring their heads off and weren't much company after their wives had spent all the morning preparing and cooking Christmas dinner.

I added I could have drowned if I could have got in to the canal to rescue said dog and the two terriers could have run off and ended up anywhere. All of us might never have been seen again, while he slept through a Christmas special of *Coronation Street* and Her Majesty's speech.

The dogs were none the worse for wear but I could not stop thinking about it. Over the next few days I asked everyone I knew locally, did they know of a man that made walking sticks? They all gave me the same answer. There were several people who made walking sticks in these parts. But none fitted the description of the man who had helped me on the canal.

I asked all my dog-walking friends, but no one had heard of him or seen him. I asked the farmer who land ran alongside the canal path and he could shed no light on this either.

I knew what had happened on that Christmas Day. I could no more have freed my dog than have flown to the moon. Ten years have passed since then and sadly my dog has passed to what I regard as 'doggy Heaven'. But for the assistance I had that day, he would have been a lot sooner.

Had I been sent a Guardian Angel that day, a Christmas Day on a deserted canal path in a sleepy village, when nearly everyone was sleeping off their Christmas dinners and my shouts of help went unheard by mortal beings?

I have continued to walk the canal every day since with other dogs but I have never met my angel in disguise, and I have a very good memory for faces.

I will never know but I will always be eternally grateful for him turning up that day; indeed, his fold-up machete turned in to a magic wand. It was truly a Christmas miracle.

In the Bible there is a quotation in Hebrews, Verse 13 that tells us: 'Be kind to strangers, for some who have done this have entertained angels without realising it.'

I really think, in fact I know, I met with an angel that day.

March of the Miners

Mrs May Thomas (not her proper name) lives in a village in the Vale of Neath. She told the following about the sound of miners eerily walking to their work place. What she experienced was interpreted for her by Mr Evan Morris. This is her story:

It was one of those late summer evenings when you savour the last of the light nights before the calendar slips in to September. My husband and I were travelling down the Neath Valley, having been for a leisurely meal, and now we slowly drove home as the sun, still bright in the sky, highlighted the mountains. All was well, and we both, as always, appreciated the beautiful landscape that surrounded the area where we lived. We told each other we could not imagine living anywhere else as this was a beautiful, peaceful place to live, with clean, fresh air, despite the fact that our village and the others in these mountains for miles were, up until the 1960s, mining communities. Once, even the daffodils were coated in coal dust, as was everything. Mining had been the lifeblood of all the villages and the wider area, and even though the mines were long gone, the legacy of the industry lived on, as one day I was to find out.

The transformation since the demise of mining owed much to Mother Nature reclaiming these hills as rightfully hers. The village we lived in was of a tranquil nature where everyone knew each other, but not to the extent it would have been years ago. Then, everyone helped everyone else: There would have been a woman who delivered the babies and laid out the dead. There would have been a parlour shop such as the one our house had been in years gone by, where children would buy sweets and men could buy three cigarettes and one razor blade, often on the slate, which got them through

until Friday, pay day. Women would sit outside their houses on long summer nights while men planned their next cricket match against the next village a mile and a half down the road.

We both loved living here as it was the way of life we had both grown up with, city dwellers we were not. Our respective families liked to visit and always remarked 'it's lovely in the summer, but it's not for me'. There's no pub, no shop or chapel, but there were three buses a day and the village did have a phone box, which was little used. My mother-in-law thought we were quite mad to want to live here. She declared it was 'the place God created but forgot to finish', but we liked it.

As wonderfully picturesque as it was, being an old area it naturally had its history. It had been a village of mining cottages serviced with just a dirt road. The house across the road from ours had been a coaching inn where travellers, weary from their journeys, would stop for refreshments overnight.

At night when lying in bed, the owls in the woods opposite would hoot in unison with a cacophony of unidentified sounds. The woods covered the side of the mountain and seemed to go on for miles. Indeed it was said that you could get lost and never be seen again. One of the men would say you could murder someone up there and bury the body; no one would ever know.

I would walk the dogs up the mountain, using an old dram road that went through the woods, where many of the derelict mine workings were still in existence. There was a building that had been a canteen for the men who worked in this particular part, boarded up for many years since. But one day youngsters who were just up to no good had broken and kicked in some of the boards. I looked in and was confronted by a sight from a museum.

There was a rough wooden table held up by bricks, on which there were a few enamel mugs encrusted in cobwebs and rotting men's jackets, which would probably fall apart if handled. There were gloves, a filthy Billy can, the kind which my grandfather would have taken to work on the nightshift in the steelworks, and a tin which would have held 'bacco, either for a pipe, or when the men rolled the tobacco in between papers as my Da did.

One could easily imagine it full of men eating their food from snap tins that their wives would have given them, eating their sandwiches with coal-blackened hands that remained ingrained with coal dust and blue scars. I imagined the camaraderie that would have existed between them all, the humour and the chivvying that went on – something that was paramount to their survival in hellish conditions. Many of them would have spent more time with each other than they did with their wives and families.

I was transfixed; I felt I had walked into a time capsule. Then, suddenly, something startled me from behind. I heard the sounds of footsteps, many footsteps. I automatically thought it was a party of walkers who frequently took members of their walking club into these woods, as the views from

the top of the mountains were a photographer's paradise. My feelings were confirmed as I heard voices and I gathered the dogs together to walk back down the way we came and to pass the walkers.

I started off down the path but there was no party in sight, and yet the sound of many footsteps and the chatter of voices continued to get nearer. There was no other direction they could have been coming from and my mouth began to dry as I pulled the dogs closer to me on their leads. The marching of the steps and the voices were now upon me and yet there was nothing there, nothing to be seen, only the sound of voices. I thought I was going mad as suddenly the sound of footfalls and voices began to pass me, as the sounds carried on up going higher up the mountain.

I was shaking from head to foot and could scarce believe what I had experienced. I carried on down the path until I came to Evan's house. Evan was eighty-odd. He had lived for many years in the former colliery manager's place and had a wealth of stories, most of which, everyone said, he cheerfully embroidered.

I dragged the dogs down the steep path to his door, praying he would be in and would offer me a desperately needed cup of tea. He was around the back of the house cutting wood as I shouted: 'Evan, Evan, please, I need to see you, quick now.' Evan came hobbling toward me,

'Whatever is the matter, *merch*?' he asked.

'Please can we go in the house, Evan?' I pleaded, 'I'm scared.'

'*Jiw, Jiw, bach,*' he replied, 'you look like you've seen a ghost.'

He sat me down by the fire, even though it was a hot day in June. Evan always had a fire burning in the grate. His house was shaded by high trees that had swayed and creaked for some 200 years over his roof, so he had fire every day of the year.

He placed a heavily tea-stained thick mug in my hand, which normally I would have reeled from, but today I was glad of the strong, hot liquid, which I suspect was laced with something a little stronger due to the state I was in.

The dogs curled up at the fireside, as I began to tell Evan what I had experienced.

He listened and seemed quite underwhelmed by what I had just told him, concentrating instead on filling his pipe and trying to light it, while patting my dogs as his own two sheepdogs sniffed suspiciously at the two visitors.

As I finished my tale, I waited for his reaction, which was not the one I expected. Dragging on his pipe he eventually took it out of his mouth and with eyes glinting, he laughed at me. I felt foolish as he clearly did not believe me and I wished I had not panicked and come here and told him so.

'Now, now, *merch*,' he laughed, 'don't be so quick, you've had your turn, now listen to what I've got to say.

'For many, many years there were loads of mine shafts up in these mountains and everyone in these valleys and for miles around came here to work. Every

morning hundreds of men would walk up these hills to get to their particular place to work. Many would have walked miles to get here before starting the shift over the mountains from the other valleys and in all weathers. There were many accidents and the men really had to learn to rely on each other. They became like brothers, playing football in the village teams and cricket in the summer, couple of pints, well many a couple of pints if truth be told. They live by each other and they walked to work together. They all spoke Welsh to each other and were in chapel on Sunday and sang in the festivals together.

'You can imagine what would happen when inevitably there would be a loss of life of one of the men from time to time, it would be devastating. There would be falls and men were trapped and everything would come to a stop as the whole village would wait, hoping there would be no loss of life, while praying if there were it would not be their husband, father or brother. Yet see, not one of them ever wanted to do anything else, it's in the blood like, you know. I was down the pit when I was thirteen as my Da was before and his Da before him.

'But eventually the industry was going downhill and a lot of the mines were closing, and sadly this one in this village was one of them. The men were devastated; they did not know anything else, see. I suppose that do sound barmy to you now?' he said.

'But there was no going back and the mine closed. It was terrible. The village became silent, like a ghost town. On the last day there were big strong men crying like girls as they had worked together for years and lost some of their buddies up there, some of them was never able to be brought out and they was left buried there where they fell.'

I could see Evan's eyes were shining as he went on: 'There were some of the finest men that ever walked the earth that I worked with, and now we were to be scattered everywhere and had to find work where we could. Many of the boys went in to the factories but nearly went mad as they could not cope with the job. I would see some of them and they had a lost look about them. One told me he used to go out the ty-bach and cry but he never wanted his family to know how much it affected him. Some died soon after, as though they had given up like.

'So you see, *bach*,' he explained, 'in some ways it don't surprise me one bit, what you've experienced. You can't wipe out generations of spirited and strong men, good men who worked in what some called the bowels of hell. They watched out for each other, they protected each other, laughed, prayed and sang together. It was the best of times for them, despite the harshest of conditions. Now they have passed over they are free to return to where they were at their best, even though many people now can't understand.

'What you heard were the boys turning up for their shift, joking with each other about parts of their lives they would not share with anyone else. They

keep each other going when sometimes a child had died or a wife had died in childbirth and the kiddies would have to go and live with relatives as a man would have to work to support them. Many died from dust and most of them, lived with the fact that that was the way it would be for them, but they never gave it a thought. They were in the canteen shouting and laughing or maybe having a little prayer service sometimes. No my girl, it don't surprise me one bit, in fact it do comfort me, as one day I hope I will march up there for my shift again. *Duw,* we had some fun sometimes.'

He got up and poked the fire to hide his feelings, which had surfaced unusually for Evan who was your rough, tough, Welshman, not given to being like a paish [petticoat] as he would say.

'There be no need for you to be afraid, *bach*', he said, 'no need at all. You've been privileged, I reckon. See they can take mining out of the valleys, but you can never take the men out of the mines.'

I walked back home and wondered if I had stumbled into a time when the past and present crossover. Did they see me and wonder who on earth I was and what I was doing up at the colliery? My experience and the things Evan had told me have helped me to see these valleys as not just scenic areas that we are blessed to live in, but how fortunate we are in just one or two generations to be spared the hardship this way of life brought to so many, and yet such was the strength of character of these men that it was a way of life they were content with.

The Railwayman

The following was told to me by the late Basil Gandy who resided in Melin Llan near Gorseinon with his wife, Sue, from the early 1960s to the mid-1990s.

Melin Llan was built around 1800 on the Penllegare Estate, and lies only a hundred yards or so from the Afon Llan, which runs at the bottom of the house's garden. Its peaceful and serene location isn't disturbed by the presence of Mr Elsden, who occupied the house in about 1890.

It seems that Mr Elsden was employed from 1912 to build part of the Swansea District Line and the 284 yards in length Penllegare Tunnel, which runs virtually under the house. The deep cutting of 40 feet exits the tunnel half a mile from Melin Llan in part of the Penllegare Forest.

Basil Gandy was walking along the footpath above the railway's cutting one late summer evening in 1968, and saw a man who was a little more than 5 feet 3 inches tall, leaning against the fence smoking a pipe. Basil could clearly see the smoke wafting up from the pipe and, of course, he could smell it too.

The fact that man was dressed in typical Edwardian clothes and the suddenness with which he appeared didn't strike Basil as odd at that time; only later that day when contemplating the events and piecing together the

various elements of what he had seen did he realise that the man was not of this world.

As Basil walked towards him the man turned and hurried in the opposite direction. Basil thought that this was unusual behaviour, because whenever he had met anyone either in the woods or the public area constructed by the Forestry Commission they always wanted to engage in conversation. But this time it was not so, and the man turned a corner and was seen no more. When Basil got to the corner there was no one there.

Describing this event to a person who had spent most of their life in the area, the name of Mr Elsden was mentioned, but he had passed away in the early years of the twentieth century. He had been in charge of the operations in laying the railway and developing the tunnel, and had lived in Melin Llan during that time and some years before.

'He was of small stature,' the neighbour told both Basil and his wife Susan, 'I've seen pictures of him and relatives of his family still live in Gorseinon or in Penllegare.' The neighbour did find the picture, albeit a grainy, sepia one but Basil nodded immediately confirming that it was the person, bedecked in Victorian or Edwardian clothing together with the pipe, who he had seen alongside the railway cutting.

Following that event Basil often walked the same route and would smell pipe tobacco occasionally. He nurtured the habit of saying aloud when he smelt it: 'Good day to you, Mr Elsden.'

The house, too, seemed to be occupied by spirits, friendly ones, because the couple would only hear noises and sometimes bumps in the upstairs rooms. It never worried them and they would speak, acknowledging who or whatever was causing them.

Most oddly, the night that man first walked on the moon, and literally at the precise time that Neil Armstrong touched the moon's surface, Basil and Susan were watching the event on the television, together with millions of others throughout the world, when the was a loud crashing sound from the bedroom above. It was followed by a loud stepping sound as though someone was coming down the stairs. This, coupled with the excitement of the moon landing, spurred Sue to run to the stairs and look up. There was nothing to be seen and the noise had stopped. Sue thought quickly and considered that Mr Elsden was or had been and engineer and an innovator, so she said in a raised voice, 'It's all right, Mr Elsden, man has just landed and is walking on the surface of the moon. Don't you think that's grand?'

The couple never heard another bump or bang from the upstairs rooms at Melin Llan, and Basil didn't see the man or smell his pipe tobacco near the railway cutting again.

Sue finished saying that they felt this was a shame because they had become quite attached to him. But Mr Elsden, it seemed, had gone. Melin Llan was at peace.

The Black Cat

There have been reports of these creatures in various parts of the country for the past forty years. In the Neath area the first reported sighting was in the early 1970s in the village of Tonmawr. This village is very close to the huge Margam Forest, an area densely packed with various varieties of evergreen trees. One morning a resident went into his back garden and was confronted by a black panther-like creature that promptly turned and jumped the wire fence and disappeared among the trees. This sighting made headlines in the local papers.

The arguments about whether there are any big cats living in our countryside continue: the authorities say that they don't exist and those who report sightings are mistaken and have seen either a feral cat or a large dog. Farmers show evidence of mutilated farm animals, and some experts say that only a feline could have caused the damage. People who say they have seen such creatures slinking away remain steadfast that they have seen a large cat. Have they escaped from a zoo or menagerie and bred in the countryside? No one has produced any actual evidence, i.e. a body. These creatures must die and surely the remains would be found. Until that happens the arguments will continue and the media will report sightings, often in a dramatic way. The large cats in our countryside have become like the Yeti and the Sasquatch, you either believe they exist or you don't. There seems to be no middle ground.

The following sighting, by Mavis Thomas, was on the banks of the River Neath between Resolven and Glynneath, in 2002. The locale is ideal for the creatures, because on both sides of the valley are the extensive forest areas of Rheola and Margam. Rob Richards of Lletty Ravel, a farm near Aberdulais has reported sightings and has had some of his sheep mutilated, the sighting by Mavis is but a few miles further up the valley.

I remember it was a Sunday and it was the time of day when a leisurely walk with the dogs was in order before settling down to finish off reading the papers. The weather was warm with no hint of rain.

The previous Sunday papers had carried stories of sightings of big cats, especially in the hills and valleys of Mid Wales. There were reports of farmers finding livestock being killed and walkers discovering huge paw prints. There were incidents of people being confronted by these big panther-like animals.

A lot of these stories were treated with scepticism and typical valleys humour. It was thought the sightings were delusions by those who were 'on something', or who had quaffed one too many at the local pub and were prone to alcoholic induced hallucinations on the way home.

Indeed that was the firm opinion of one dogwalker who had read these accounts in the local paper. Men had gone armed with guns and shovels to hunt down the Beast of Brecon or the Ponty Panther. How could these

creatures survive in the harsh winters of these valleys? Where had they come from? It was nonsense of course, from people who wanted their name in the paper and fifteen minutes of fame.

Until that September Sunday afternoon, when I walked my two dogs along a path by the River Neath. I had stopped and was just idly watching the river. The dogs were off their leads and were mooching. The area is idyllic. The trees were glowing with rich shades of rust and gold as they prepared to shed their foliage for the long winter rest. The only sound was from the vehicles passing on the bypass (the A465) and we had got so used to this that we hardly noticed it.

One of the little dogs was just a puppy, three months old, the other a Jack Russell terrier. I was lost in the tranquillity of the scene, suddenly something caught her eye, and much to my astonishment, a black animal slowly sauntered in to view. It moved slowly and then shifted out of the sun's glare and into the shadow caused by the bypass. At first glance I thought it was a large dog but it was too big, and as it moved to the water's edge I could see it was cat-like. Its movement was graceful. It was one of these panther animals I'd seen in the papers.

I was rooted to the spot and then the puppy beginning to squeal. Slowly I bent down and attached the leads to the dogs. I didn't want to attract this animal's attention to me or to the dogs. All the Hollywood movies of explorers on safari confronting huge beasts and bravely walking backwards much to the admiration of everyone in the party came whizzing onto my head. What were the chances of putting into practice in the Welsh valleys something you had seen on a Saturday morning at the cinema in the 'two penny rush?' It was crazy, but it was actually happening.

I pulled the dogs closer. The river being very low, it would not have taken many leaps and bounds for this magnificent black cat to cross the river and make his way up the bank towards us. Instinct said that I should go, leave, get to safety; two little terriers would have made a tasty teatime treat for this animal. But wonder and incredulity rode roughshod over common sense. There might never be another chance in this lifetime to witness this scene again. Pity I didn't have a camera with me.

The sun shone on his slinky black coat as he drank nonchalantly at the river's edge, my feelings veered from hoping someone would come if only to witness this unbelievable sight and confirm I was not suffering from the effects of the cooking sherry, to praying no one would crunch along the path and send him scurrying away, or indeed vaulting the river and ending up by my side.

The cat then lifted up his head from the water and stretched in the same manner the ginger tom at home would. He looked around, surveying the area, and then with a majestic swagger, glided off in to the dense undergrowth and under the bridge without a backward glance.

Hardly believing what I'd seen, I was overcome with a mixture of relief that he hadn't spotted me, an intense longing to have viewed more of his activities and for longer, and also the shock of recognition that those like me who had been privileged to witness this beautiful animal were not nutters as I had previously labelled them, in much the same way pilgrims travel to Medjegore and witness visions of the Blessed Virgin there or travel to Lourdes and experience healings of various physical ailments are often treated with suspicion and derision by those who adopt a no-nonsense approach in these matters.

When I arrived home I was unable to do justice to the scenes I had witnessed. Mere words could hardly convey what I had seen. When I related the story to my husband, we decided to tell no one. The last thing we wanted was for the poor animal to be hunted down and shot. The dogs and I were unscathed and the cat was more alert to his own safety than posing a threat to us, we decided.

So we told no one, not just to protect the whereabouts of the big cat, but indeed lest I was labelled a nutter, as I had previously decided those who gave accounts such as this were.

A few years later, we were visiting farming friends a few miles away and the conversation turned to 'things weird and wonderful'. They had riding stables and a few acres, and one morning our friend was crossing the yard to go to one of the barns, when he stopped dead in his tracks. There before him was a huge black cat, taking a big drink from an old sink they kept in the yard. He stood perfectly still as he knew if he turned and ran the cat was that near that he would have gained on him in no time. He could hardly believe it was happening. Suddenly the cat looked up and, upon seeing our friend, took off across the fields at great speed.

He also told no one, half in fear of being regarded as crazy like I had. Maybe a few whiskies shared together had loosened his tongue and knowing he was among friends, decided to reveal his experience.

When I related my experience to him, he was overjoyed that someone else had witnessed what he'd seen. He also felt privileged to have been allowed to see the big cat in all his glory. At no time had he found dead livestock, as had been reported in some instances.

He had come to the conclusion there must be more than one such cat. You can walk for miles and miles in the forests and should you fall or get hurt in some way it's possible you'll not get found. The forests and mountains are teaming with wildlife and if you lie in bed at night and listen to the midnight orchestra of sounds, it can be difficult to identify each one.

In this hard-nosed world of ours, we have lost a sense of the mystical. There are indeed 'more things in heaven and earth', and things that we will never understand this side of life. But just now and then, the curtain is slightly peeled back, and those who are granted the honour of taking a momentary glimpse are indeed blessed, as I consider I was that day when I encountered the large black cat in the Neath Valley.

Waun Fraith Colliery, Court Herbert, Neath Abbey

There have been several reported hauntings in the Court Herbert area: the site has had a few incarnations: around the twelfth or thirteenth century it became a grange of the Cistercian order of the Neath Monastery. Following the Dissolution of the Catholic monastic orders in Britain (1536–39), the grange became a large house or mansion until the 1960s. It was occupied by various families, one of which was the Gronows; certainly from the middle of the eighteenth century much of the land was taken up by colliery workings. David Rhys Phillips concludes that Waun Fraith colliery predated and was on the same site as the better known Court Herbert colliery. Also on the land is a Maen Hir or standing stone; about its origin we know little. From the mid-1960s the area has become a fashionable private housing site.

People have reported that a monk is sometimes seen in the area. Some of the house-owners there have been startled by strange knocking sounds, usually at night and some have said that a shadow, quite indistinct, has passed through the rooms of their homes.

Of events in history that could be the catalyst for such disturbances, on possibility the legend about the monk or lay brother who passed information about the route the sovereign was to take on leaving the place to the enemies of King Edward II, who had taken refuge in the Abbey in 1326. On leaving the Abbey the King was captured and put to death. The abbot on learning that it was a brother or lay brother who had divulged the information, so the story goes, rooted him out and put him to death, then buried his body outside the precincts of the Abbey in unconsecrated ground. Could this be the monk seen at Court Herbert?

Or could the disturbances be from the colliery accidents, there were quite a few. In 1758 seventeen men died at Waun Fraith; and twelve years later at the same pit in June 1770 ten men died following an explosion; and at Court Herbert colliery on 1 June 1906 five men were killed underground.

So there has been quite a lot of heartache and tragedy that could have left an imprint in the ether that is still seen and felt to this day.

In respect of the accident recorded at Waun Fraith in 1758 the following was penned by the poet Ben Simon:

Boneddigion a gwreng Ddynion
Gymru mwynion glo'wion glan,
Gwrandewch oernad Drwm Alarnad,
A mawr gwynnaid yma ar Gan:
Yn Llangattwg ym Morgannwg,
Angau mawrddrwg sy ar waith,
Yn taro ergid tra dychrynllyd,
Ar weithwyr hyfryd y Wern Fraith.

Mil Daethcant deunaw Mlwydd a Deugain,
Bu'r Drift Ddamwain ddirfawr grud,
Amgylch Deg ar gloch nos Fercher,
Daeth y dirfawr drymder drod:
Y pedwerydd Dydd ar hungain
(Mawr yw'r ochain) o Fis Mai,
Dau ar bymtheg gas eu terfyn
Er mawr ddychryn I bob rhai.

Ghostly Light that Haunted Maesgwyn Open Cast

This story originates from the late 1920s and was told to me by the Neath Guardian journalist, the late Wally Thomas in 1967.

The Maesgwyn Mine is located between Banwen and Glyn Neath and predates the open-cast workings and recalls a time when Maesgwyn was nothing more than a few cottages and a drift mine. Maesgwyn has featured many times in the news usually relating to concerns regarding environmental matters. But more than ninety years ago the miners there were shaken not by the prospect of environmental protesters but by a ghostly light.

The Vale of Neath is well furnished by stories of 'ghosts and goblins and long-legged beasties and things that go bump in the night'. Thinking of that that dark, winding road on the western side of the valley, passing the evocative lights of the lonely pub called the Rock & Fountain and through the dimly-lit hamlets of Ynysarwed, Abergarwed, Rheola and Pentreclwdau, at the beginning of the nineteenth century, the imagination can conjure up visions of shadowy coaches pulled by shining black horses. The clip-clopping rhythm and the cold shouts of unload and load at the coaching pubs, the Rock and the Stag as they meander towards Glyn Neath, Merthyr and all stops to Gloucester; or the other way down the valley heading for The Castle Inn at Neath. The crack of the driver's whip and the 'whoa' would hold on the wind with a restlessness of the angry Afon Nedd as she collects water from the brooks and streams, which feed down from the steeps hills on a winter's night.

Maesgwyn was lonely. The cottages were isolated. The roads are narrow and high hedged, and are no strangers to the Cannwyll Gorff and ghostly funeral procession that can wreck a man who is unfortunate enough to get caught in one. And the miners who worked the coal were shaken by a strange light which moved silently among them.

Many of the miners testified to seeing the light but none of them could distinguish anything which would explain it. But it left them in great fear and many refused to work in the general area in which it was seen.

'Like a stage-coach lantern,' said one miner, 'it glowed with a yellow light and moved down the bank. Then suddenly it disappeared only to reappear

some 50 yards from me. I was terrified and ran off.'

Several theories were put forward but none could explain it. The miners had cut into several old workings: had this work disturbed something? But the fact that an old cottage had been demolished to make way for the coal workings was a favoured theory for the sudden appearance of the ghostly glow, because every time it disappeared from the miners' sight it was at the location of the demolished cottage.

Was a past occupant of that dwelling protesting about the continued development of the colliery or was it foretelling that one day this area would be smashed and broken up for open-cast coal mining?

It is not known what became of the yellow light or if it persisted for any length of time. No rational reason was ever found to explain it. But many of the hard-bitten miners would not work there after seeing it. Was progress too much even for those who move in the spirit world when the day light fades and the loneliness of the night reigns?

My Own Guardian Angel

In 2008, Mike Davies a respected wildlife photographer from Cadoxton, had been suffering ill health for many years, but the culmination of his medical problems reached a salient nature when he was diagnosed with a serious heart complaint that needed urgent surgery. Mike takes up his story:

The news that I was suffering from a heart condition was yet another devastating blow to my entire family. There was history in my family regarding similar afflictions. My father had died from a heart compliant twenty years before. I had been ill for several years with various illnesses but in the months leading up to this most recent diagnosis I had found great difficulty in walking more than a few yards without having to sit down and rest, I was breathless and very tired even by walking from one room to the other.

My doctor referred me to Morriston Hospital for tests and literally within a matter of days I heard that I urgently needed open-heart surgery for a mitral valve replacement. The surgeon was quite candid and told me that if I didn't have the operation I would be dead within a year.

I sat there just holding my wife Maureen's hand. My mind was whirling, thoughts of my father, Vernon, flooded back to me. The surgeon continued: 'It's quite likely that your father suffered from a similar condition. You have a chance, but I want to operate almost immediately.'

I looked at Maureen, fear was pounding through my veins. I accepted the fact that today the medical profession was quite brilliant and it seemed that there was no end to what its practitioners could perform. I had often spoken to friends who were going to undergo an operation and had tried to

encourage them about the genius of doctors and surgeons, but the stark fact was that I was now told that I must have an operation, and that if I didn't then I would not see another birthday, was mindblowing.

'I'm thinking of my dad, Maureen,' I said.

She nodded back to me. I could feel her hand trembling in mine. The surgeon waited.

'Okay,' I said, slowly, nervously, 'give me the form, let me sign it.'

That done, he picked it up and said that he hoped to fit me into the schedule as soon as possible. 'And I mean that,' he said. 'It could be a few days. Be ready and don't worry, I've performed many operations like this,' he added, smiling.

Maureen and I left the hospital in a daze. She phoned close members of the family and a few friends to let them know. I phoned my mother, who was naturally worried and considered my father's heart complaint.

The surgeon had certainly been right about the timescale. Just a few days later we were informed that I was to be admitted on 9 October, and the operation would be carried out the following day.

That night in the hospital bed I didn't sleep much, I did nap for brief periods but all too soon the reality of what was to happen would flood over me. I tried to reason to myself that up and down the country there were many people in my situation, but somehow this did not help. I watched the dawn break across the mountains above Neath and wondered whether I would again be walking slowly, quietly towards some bird or animal, camera at the ready, hoping to record its habits in some journal or other. I thought of Maureen alone at home in our bungalow. She said she'd be in the hospital later that morning. And then, all too soon it seemed to me, the nurses were busying themselves preparing me for the operation.

They were cheerful, asking me about the photography, then an injection. 'This won't hurt,' and as she said it the needle was withdrawn. Marking her professionalism, it didn't hurt at all.

The surgeon came into the room and asked, 'Ready, Mr Davies?' He mentioned a few things that I didn't really hear. I tried a smile and a nod and soon I felt the bed move and I was on my way to the theatre. Before the bed had gone through the door of my room I was unconscious.

I learned later that the operation had taken eight hours and it had been a further three days before I eventually woke up. Any pain that would have been caused by the huge incision that had been made in my chest and the resulting sewing up had been nullified by drugs. I was in wasn't back in my own room but learned that following the operation I been admitted to the Intensive Care Ward and then later again to the High Dependency Unit. It was while in this unit that something strange happened.

I have absolutely no recollection of what happened throughout my operation. Not for me was there an 'afterlife experience'. One reads about such things when a patient claims that during the operation he or she was

watching from above as the surgeons worked. Sometimes I wish I could say that I did have such an experience. I like the unusual, that's one of the delights in being a wildlife photographer; you see some strange behaviour and can record it and subsequently publish it. But no, my operation is a complete blank. But as I lay in the High Dependency Unit, constantly being monitored by nurses, a white feather had floated down and landed on my chest. It rested on the gown that was covering me, but right on the scar line of my operation.

A nurse saw it and almost freaked. 'What's that?'

'A feather,' I said, 'it just floated down and landed on me.'

'But it can't have,' she said, 'you're in a sealed unit.'

'Well it did,' I said.

She carefully picked it up and took it out and put it in a small plastic bag and placed it on a table. She shook her head in disbelief and went out.

She returned with a colleague and pointed to it. The colleague said 'but how could it have been in the unit, it's sealed? And it certainly wouldn't have been on the floor and picked up by a draft of air. Nothing moves in here unless we say so.'

Both nurses looked at me and almost simultaneously said: 'You have a Guardian Angel and it's watching over you.'

Mike added, after relating the above, that he has heard of feathers being a sign from beyond the grave, particularly white feathers.

I made a complete recovery. Soon after being discharged I was told to walk as much as possible and I did. I started taking my dog out, armed, as always, with my camera, and found I was no longer breathless; I could breathe deeply and was utterly relaxed. I kept the feather and I like to think was touched by my Guardian Angel. It is still in the plastic bag that the nurse placed it in. Was the feather a means of saying that my time on this Earth was not yet up,

Mike Davies holding the feather that appeared on his chest.

despite a serious operation. I take the feather out of the bag sometimes and touch it, and I feel I'm in contact with an entity from beyond the veil.

Victoria Gardens

Stroll into the peaceful Victoria Gardens on most days, particularly in fine weather, and you'll be lucky to find an empty bench on which to sit. Often you have to share with a stranger, and if that stranger, with the best will in the world, wants to talk then your contemplation can be spoiled. Bill Mansfield lives in Briton Ferry, is forty-eight years of age and has worked in Neath for many years. Always during clement weather he has spent his break from his office, his dinner hour, in the gardens, eating either chips or sandwiches, and sipping tea from his flask. He enjoyed the peace just sitting and thinking, watching people hurry past, children playing and the sparrows and pigeons searching for food and quarrelling with each other when the find it. Always on entering the park his first thought was, where's an empty bench?

> As a creature of habit I tend to sit in the same area of the gardens to eat my food. When the weather is nice there is no better place in this town. It is so peaceful even when there are children about, their running about and calling each other doesn't tend to wreck the tranquillity. I like to sit on the side of the gardens that is parallel with Alderman Davies' Church in Wales School.
>
> It was a Tuesday and I was fortunate to find a bench empty near the monument to those men from Neath who gave their lives fighting for democracy in the Spanish Civil War from 1936 to 1939. I settled down to read the paper and eat my sandwiches. A few people hurried past. Most of the other benches had people sitting on them, and just as I like to be I was on my own yet among people.

The park was formed as part of the town's celebrations for Queen Victoria's Diamond Jubilee. Neath Borough Council decided to create a park in a prime location. The Council owned approximately 2 acres of land called the Corporation Fields, which was considered a suitable place to develop a park or gardens that could be a peaceful haven for the residents of Neath to relax.

Mr Thomas Snow, a local builder, was commissioned to fulfil this task and what we see today has changed only slightly from what he originally envisaged and ultimately developed. Mr Snow's ideas have been added to, with the placing of the Gorsedd Stones, the Howell Gwyn statue and the by which Bill was seated. The bandstand was a facet of Mr Snow's ideas and has remained in place since the time when the gardens were opened to the public in 1897.

The area of land now occupied by the gardens has had many incarnations. It was the site of the Gnoll Colliery in the seventeenth century, owned by the

Mackworth family of the Gnoll; it's been called the Mera Field, the Corporation Field, the Recreation Ground, and finally Victoria Gardens.

In 1856 Neath Council purchased the land, known as the Mera Field from Henry John Grant of the Gnoll to enable it to own an open space in the centre of the town, from that time on it was called the Corporation Field and played host to cricket and rugby matches and also was the venue for the annual Neath Fair, The field continued to host the fair until 1897 when a commemoration was planned on the site for the Monarch's Diamond Jubilee.

Reference to the Mera Field is interesting. David Rhys Phillips gives us the following description of the origin of Mera and about the people who lived there:

> The word Mera is of ancient use for the district around the top of Water Street – probably of marsh designation. *Gwyr y Mera* – the inhabitants of the Mera: a group of collier cottages mainly dating from the end of the 17th century. Many of the travelling tinkers and hucksters of the valley were drawn from this place. They came from Shropshire and other parts of England to work at the undertakings of Sir Humphrey Mackworth and the Mines Adventurers, developing in time a Welsh patois which they spoke with a Welsh intonation that wasn't unpleasant. *Merched y Mera* were the Amazons of Glamorgan. They travelled the valleys on foot, vending crockery, cockles and other wares. *Wheugan o ferched y Mera* was a phrase for a group of ten.

So, Rhys Phillips identifies the Mera area for us: on the wall of Alderman Davies' School there is a plaque which informs us that this was the site of the Mera cottages.

The reference to Amazons implies that the Mera community was matriarchal and indeed Neath has its own story of 'Nell Downey, The Queen of the Mera'.

Bill continues:

> I'm familiar with the history of the gardens. The new Community Facility Building at the top end of the park has published a brief history of the place so I know about the Queen of the Mera and all that. As I said, I like to sit in this peaceful setting and alone yet amongst my own people – although I'm from Briton Ferry, I was born in Llantwit and love the place.
>
> As I said, I managed to find a bench near the stone for the men who died in Spain, I was glancing at the paper and I saw a woman walking towards me, coming across the grass. I took little notice but did see she was had a shawl draped around her neck and coming together near her waist. She was walking quite quickly and then she stopped. Now I was looking intently. I'd never seen her before, and I know quite a lot of people who come into the park, if not by name then certainly by sight.
>
> She stood quite still. There were a few pigeons searching for food near her; this is not unusual because you've almost got to step on them for them to

move. She had grey hair, no hat, and a pair of glasses perched on the end of her nose. Her skirt reached to her ankles. I realised I was staring, so I poured tea from my flask. When I looked up she was still there. Then she started to walk, slowly, this time towards me until she came to the tarred path and said in a quiet voice, 'can I sit here?'

I nodded and said 'Yes, of course,' and moved my flask and paper towards me, giving her room. She sat down and smiled, but said nothing. Many, many times I'd have to share a bench with someone and I never minded really, but this lady just kept looking at me without a word.

I was uneasy and thought I'd say something. I said, 'I haven't seen you in the park before.'

'Haven't you?' She answered, and added, 'Well I'm here all the time,' and she smiled.

Remember, I'm telling you this as I recall it from that afternoon. I was thinking she was odd but nothing more than that. But her deep-blue eyes were piercing and I had to glance away. I am the one who is usually reticent about make conversation, particularly there, because I enjoy the peace and the break from the hectic work in the office, but I felt the need to talk to her. I remembered I had some biscuits and offered her one.

'No,' she said, 'I don't have use for them,' and that was that. She said nothing more and nor did I but I couldn't relax to read or eat the rest of my food. I was beginning to feel annoyed that my desired aloneness wasn't to be on that day.

The town clock struck the half-hour and I decided to go. I said aloud 'It's time to go now,' and I rose to my feet, gathered up my flask, paper and bits of rubbish. She got up too, and left without acknowledging me, walking towards the gate opposite the Cross Keys pub, in the same direction as me.

She moved with a strange ungainly gait, she seemed to sway from side to side, her skirt flapping about her ankles. I was transfixed and I don't to this day know why, why I should have been transfixed or curious, but I noticed a few pigeons picking at things on the path directly ahead of her and she walked right over them and they didn't move. I couldn't believe my eyes! It was a lovely, warm day, but I suddenly had goose pimples. They birds didn't move. She then turned left just before the wrought-iron gates that led out onto Gnoll Park Road; indeed she seemed to be heading into the bushes. She then turned around to face me and smiled and disappeared. She just vanished in front of me.

I really did hurry to the office but didn't mention anything to the others there. I was still trying to make sense of it. But I did realise I hadn't imagined the meeting. I did see a ghost. This is the first time I've spoken about it, I have read some of your stories about ghosts in Neath and knew that you wouldn't ridicule me.

Bill's story has a resonance with others I have heard: many deeply religious people will argue 'that they walk amongst us', meaning that people we might see walking in a street might be from another place that is not of the world we know.

He felt easier after the telling of his tale. He knew the history of the Gardens and knew that a row of cottages purchased by Neath Council in 1856 had been demolished. This woman who, for whatever reason, had chosen to speak to Bill, had turned into the bushes and disappeared. The row of cottages was at that precise location.

Was she walking the area, of course, the field that was once the Gardens, would have looked completely different to what we have in the twenty-first century. But maybe she won't let go of her time in Neath, maybe a period in time that reaches back nearly 150 years.

I asked Bill if he continued to eat his food in the park? He said he did, and if he encountered the woman again he would try and be more concise with his questions. 'I'll let you know if it happens,' he said.

Best of luck with that, Bill!

ROBERT KING

NEATH

THROUGH TIME

Neath Through Time

Robert King

This fascinating selection of photographs traces some of the many
ways in which Neath has changed and developed over the last
century.

978 1 84868 585 7

96 pages, full colour